741

Sign Language

Street Signs
as Folk Art

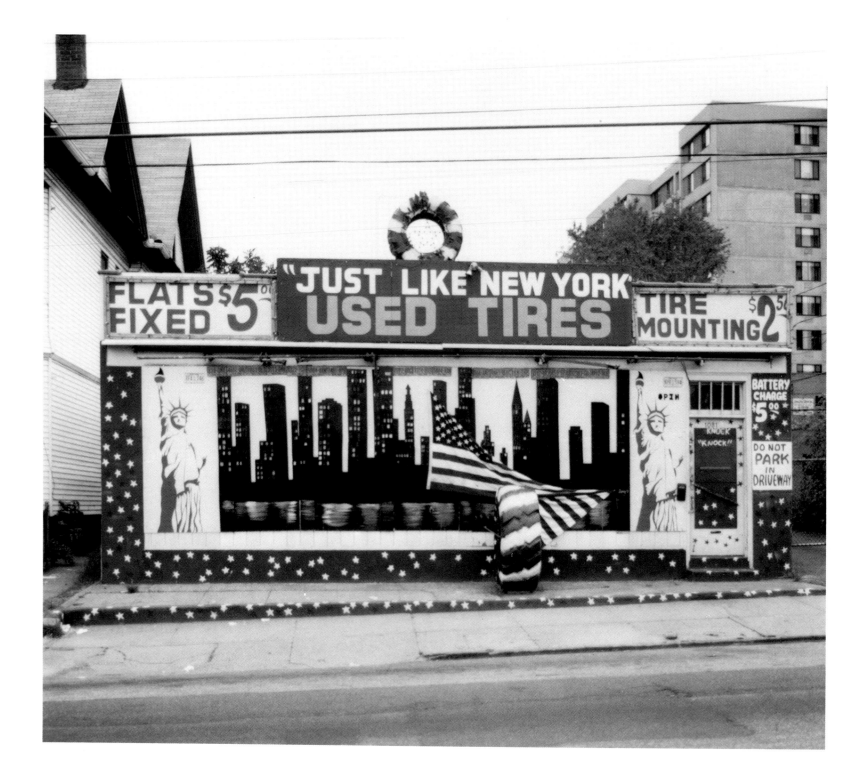

Sign Language

Street Signs as Folk Art

Photographs and text by John Baeder

Harry N. Abrams, Inc., Publishers

DEDICATION

To all the people who took an idea, a tool, a surface, and through their hearts and souls expressed thoughts, needs, and feelings—and created signs of everlasting beauty: a new-found poetry and language of the street.

And to the memory of Russell Miller, Jr., and Ken Kneitel, who were there from the beginning.

Editor: Robert Morton
Designer: Joan Lockhart

Library of Congress Cataloging-in-Publication Data

Baeder, John.
Sign language : street signs as folk art / photographs and text by John Baeder.
p. cm.
ISBN 0–8109–2642–3 (pbk.)
1. Photography, Artistic. 2. Street signs in art. I. Title.
TR654.B215 1996
779'.96591342'092—dc20 95–34057

ACKNOWLEDGMENTS

This book is perpetual. It will never be completed. Anonymously painted signs keep multiplying and replenishing themselves. No words can describe my gratitude to all the spirited souls who needed to express themselves and allowed me, without invitation, to enter their world for a fleeting moment. Many kindred spirits have been with me on the lengthy journey. From the earliest beginnings two important and pivotal friends must be remembered: Norm Kohn and Sol Malkoff. They were the initial catalysts, the great encouragers. They are continually appreciated and loved.

Giant kudos and thanks to the many who have left an indelible light: Marna Anderson, Margot Baeder, Joan and Darwin Bahm, Jane Braddock, Bill Christman, Dan Cranor, Dave Damer, Catherine Darnell, Michael and Gayle Eastman, Suzan Fritz, Marilynn and Ivan Karp, Nathan "Pedro" Lewis, John Marcus, Jayne McGuire, Marilyn Murphy, Griffin Norman, Janice Pollard, Bill Powell, Robert Reeves, Dee H. Richards, Tom Ryan, Jackie Sideli, Ken Speiser, Gary Thompson, Joan and Bill Vogel, Perry Walker, Bobbie and Bernie Weinstein, and Maxine Yalovitz-Blankenship.

For his unique vision and needed wordsmithing, I pay immense gratitude (and the King of Patience award) to my editor, Bob Morton.

And lastly, to my dear friend, the late Rusty Miller, who aided me with f. stops, souping, and dodging.

In order to swim one takes off all one's clothes. In order to aspire to the truth
one must undress in a far more inward sense, divest oneself of all one's inward
clothes—of thoughts, conceptions, selfishness—before one is sufficiently naked.

—Soren Kierkegaard

Early in 1962 I bought a camera. A real camera: a Miranda-D, 35mm SLR with a 50mm 1.4 lens.
It was simple and effective, good enough for me because I wasn't quite sure what kind of pictures
I was going to take. I knew the urge was there, full blast. Actually, I wanted a Leica M-2, but that
was a real "pro" camera and I didn't feel I belonged in that category. Besides, it would have been
pretentious.

I was a twenty-three-year-old art director at the hottest, most creative ad agency in Atlanta, a
New York-based shop where, in 1960, I got my first start in the business. Conceiving ads, execut-
ing layouts, designs, and sales promotions were some of my responsibilities on several accounts.
And more. Being a sharp little art director wasn't enough for my creative juices, which is why I
bought the camera: there was a calling out there somewhere.

To remove myself from the agency climate, I rented a small room in an old house. It was my
studio. The house belonged to an architect who occupied the downstairs. (He wasn't very good,
and years later hanged himself.) Upstairs was an old college friend, Norm Kohn, an illustrator and
graphic designer. (He was very, very good—the best in town.) Norm was responsible for my get-
ting the job at the agency, and he remained a pivotal figure in my life.

Thanks, Norm. And thanks for letting me share that extra room of yours at 7-17th Street,

where extracurricular juices flowed—drawing, painting, assembling collages, entertaining, hiding out, and a host of other life-affirming activities. But that wasn't enough.

That's where my trusty Miranda comes into the picture. I used it on my frequent weekend sojourns scouring the raw-textured underbelly of Atlanta: an Atlanta that was beginning to fragment, an Atlanta that was a long-forgotten song, an Atlanta yawning a new dawn.

There were still remnants of the vital, yet serene southern city that was burned to the ground in the Civil War, and was rebuilt, and grew and grew and became the Gateway to the South. I was more concerned with the texture that no one cared about or visited—Atlanta's shadow, where peeling posters and musty windows blurred into doorways that went nowhere. In that nowhere was the patina of past lives lived and lost in agony, layered with shining hope. This was the beginning of my understanding of a visual language of the street, a language that I would grow to love. The substance and the significance of it all wasn't immediate; it evolved.

My visual investigation had begun simply. It was based on the roadside images that haunted me while I traveled the back road (Route 29) from Atlanta to Auburn, Alabama, during college years. The three-hour journey was along a highway of lean-tos, rinky-dink motels, two-bit gas stations, and shacks: all were covered with signs (hand painted and manufactured). Sign collages for cola, beer, cigarettes, and the like were scattered on all sides.

Closer to home and later in my life, my explorations of Atlanta's black neighborhoods were the most engaging, reflecting history, cultural texture, and, above all, expression. Russell Miller was my comrade, in spirit and travel. Rusty was a professional photographer who shot many an ad for me at the agency. We were pals, and on weekends Rusty and I would scour the neighborhoods that few, if any, white folk cared for or knew about. We drove Rusty's black VW Beetle convertible, in those days a high-visibility auto. This was the early 1960s. Racial strife was all

around, but the malaise didn't deter us. We felt comfortable with our "brothers," our friends, who just happened to live in another neighborhood. We were warmly accepted. They sensed we were two men on a mission, inquisitive, enthusiastic, and passionate.

We photographed many people being themselves. Particularly exciting were the children, so free, loose, expressive, and loving. The adults were more reserved, often skeptical, always asking if we were from the newspaper.

Rusty enjoyed his involvement with adults and children. I was more focused on the graphic evidence, the physical marks left from people's hearts. My early passion for the road signs of Georgia and Alabama transposed itself into the urban environment. This filled my combination plate.

After a day's shoot, we'd immediately develop the film. The darkroom became addictive for me; I got lost in making prints. The studio key opened the door to solace, and a meditative, creative experience that would often last into the early morning. I

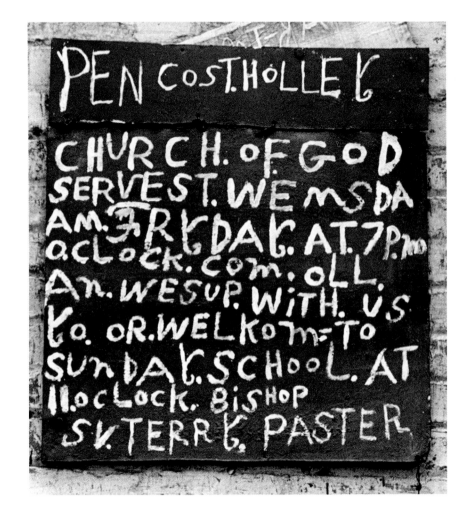

believe this was my first transcendent experience, spending hours of discipline and joy watching the image develop. Magic. Miracle.

During one of our tours on a Saturday morning, meandering through neighborhoods, and getting lost, we came upon a storefront church, so common in black neighborhoods. It was in a

boarded-up building that sat with dignity in the middle of the block. Buildings on either side looked as if they were hugging the church, holding it up. A simple sign was to the right of the entrance door. It was a handwritten notice for a Pentecost Holy Church.

I did not know it then, but this was a cosmic event in my life, a major turning point and the beginning of a thirty-year quest.

I didn't really see what I had photographed until the image came out in my hands as a print. Then I knew. It was so poignant. I loved the cadence, the beauty, the sound of southern blacks speaking. The words were pure music to my ears. This is an observation that I find difficult to describe, but the church sign speaks to me in that same sound and rhythm. It held my heart and tugged it gracefully.

The sign was the beginning of a long journey that took me to more signs, and brought more signs to me. I believe that I did not discover the sign—it discovered me.

Nashville, Tennessee

The dramatic effect of seeing the "Pentcost. Holley" sign in 1962 was the beginning. The photographs reproduced herein are merely further documentation of a collecting idea that was born then. But the idea goes back beyond thirty years ago, and is as recent as last week. Time condensed.

My collecting interests began when I was about five years old. This, I believe, is the normal time when both orders and disorders start their little path down the road that hopefully leads a child into properly channeled development. I had a curious, investigative imagination like most kids my age. Mystical beginnings?

A highly momentous occasion of collecting happened directly across the street from my home at 1697 Noble Drive in Atlanta, Georgia. There was a serene little park with stone inlaid walkways and pine trees where "colored" help, and sometimes real live mothers, would park and stroll their children. The park marked a turn-around for the bus line. The buses, small, flat-backed, gasoline-powered Whites or Twin Coaches, would stop directly in front of my house and take a rest. The driver would get out, have a smoke, catch a brown bag lunch, or take a snooze. Sometimes he'd sit in one of the seats and read a leftover newspaper, or take a walk and say "howdy" to the kiddies, maids, and moms. I believe this was my first observation of ritual outside my home.

After remounting the bus, the last thing the driver did before departing was to hand crank the destination sign. It went from 16 NOBLE to 16 SYLVAN HILLS. To my young eyes, this was a mini-event. The major event took place directly after departure, as the bus climbed up the curvy Noble Drive and made a right turn on its first official stop on Johnson Road. (When we moved to Johnson Road a few years later, that first stop was *my* bus stop.)

Back to the park. I'd ask Murdice, our maid, or my mom, or both, to dig down in the trash barrel and retrieve the bus transfers discarded by disembarking passengers. These objects were pure joy for me, and collecting them began a quest. The transfers were printed on multi-colored paper—light yellow, light green, pink, blue. I can't recall if the various colors meant anything. I certainly wanted them to. This attention to detail was important to me. Aside from the paper, the most significant feature of each transfer was the diagonal cut along one edge of the paper, giving it a fully used look. The cut was the mark that denoted the time the transfer was given, which was indicated in vertical numbers running down right and left margins. The numbers and the other design elements on the transfers made me excited, and the idea that they were plentiful was even more appealing. Every day I would load up on more and more used transfers. I would even trade to myself for newer ones. Soon I had a collection, but I didn't know just what to do with it. After all, I was a restless little boy of the 1940s, and didn't have any visual adventures such as television or the goofy hand-held games that kids get involved with these days.

My other collection, of sorts, was nestled under my bed in the "parking garage." These were my toy autos. Every month, after New York City trips, my dad would bring back a toy car, an elegant body with four rubber wheels. Not surprisingly, this passion manifested itself later on in my life, starting in my thirties, when I began buying my own collection of toy cars, buses, and trucks.

Along with my early collection of toy cars, I conceived a need to have the sales catalogues of all the grownup, full-size cars. At my request, my mom would drive me to every automobile dealership in town, where I would gaze at the shiny cars in the showrooms. Meanwhile, she would explain to a salesman that we were not interested in buying a car, but that the intent of the visit was to satisfy my need to have all the latest catalogues available. Now I recognize these jaunts as what psychologists would call early "demand behavior," with overtones of compulsive/obsessiveness.

But it was a good start, for me, and I believe a healthy one, too. This was the artist in me at a very early stage. I didn't know it was merely a case of getting my visual needs recognized.

This visual hunger began to manifest itself with magazines. Our household always had the basics: *Time, Life, Look*, and a plethora of others. They were not enough for me. I was not a scientific or mechanically inclined kid, but I loved cars and technical things. Moreover, I had an attachment and fascination for page layout with all kinds of pictures that dealt with anything a bit askew. The satisfaction of this visual hunger was easy; I began to subscribe to *Popular Science, Mechanix Illustrated*, and *Popular Mechanics*.

The surprise of receiving these magazines in the mail each month was pure delight. On one level it was a great escape: satisfying visual hunger through the mail was a diversion from the everyday trauma of doing homework, and I am sure this activity contributed to making me just an average student. Plus, during this period television was new—brand spanking new. The novelty of being a first-generation TV junkie was not felt until later on when I reflected back on how I skipped through classes, taking minor interest in the important courses, because my real desire was to go home and turn on the TV and check out my latest magazines, which not only included the above mentioned, but also every single airplane magazine available.

To complement my intense interest in aviation, I started a collection of World War II and post–World War II airplane photographs. These were pictures by specialist aircraft photographers and executed by a camera that produced an image measuring 2 ¾ by 4 inches. There were only a few sources for these amazing pictures: Leo J. Kohn of Milwaukee, Bob Stuckey of La Crosse, Wisconsin, and Aeroplane Photo Supply in Toronto, Canada. We had a steady correspondence. My greatest excitement was placing an order. The anticipation, waiting impatiently for the package to arrive, was arousing. This carried me through boring days of school, schoolwork, and day-to-day

suburban living. Coming home from school, going through the mail and finding the tightly wrapped package was pure bliss for me. I'd carefully unwrap and pull out the pictures. I never knew what to expect, although I knew what type aircraft I had ordered. The surprise factor was

extremely emotional for me. I would always be astonished with the newness, the fresh look, or a special angle I had never seen before.

I'd mount the photographs on 4-by-6 inch cards and type in the proper designation under the photo. That was all, except to file them alphabetically by manufacturer in a wooden file box. That box eventually overflowed into another larger, longer file box. They are still with me.

The romance of World War II was and is enormously popular, and it is also a big business. All I cared about was the visual satisfaction; it gave me pleasure and also led me to other collections. What fascinated me the most about the aircraft was their design, their look, their attitude on the ground and in the air. The mass of metal represented sculpture and graphics at its peak. I wasn't much concerned about their use as weapons. It was their aesthetic that spoke to me.

Along with my interest in the aircraft as sculpture, there was another level of visual power, the various markings on them: letters, numbers, signs, and symbols that identified aircraft from the various services, the Army Air Force, (later, United States Air Force) Navy, or Marines. Discovering what the markings represented and how they were used was a long and intense study; at first a total mystery to me, but I loved the suspense. Through the years, more serious books were published. Now, I collect those books. The mysteries have been solved.

My collection of aircraft photographs was supplemented by model making. Back then, in the dark ages of the early 1950s, the Strombecker line of wooden model airplanes was popular; they

could be bought at the local five and dime store. The Strombecker line, now nearly extinct, is still highly sought after. Strombecker models, unbuilt or built, are collector's items of high order.

These were my wonder years, when early obsessions and fascinations became collections and served as unconscious instruments for later collections. The later high school years were typical, full of raging hormones, dates, drive-ins, and dances. We listened to the early roots of what is commonly known as rock-n-roll, but for us lucky souls in the middle 1950s, it was pure hard-core, five-star, bold-face rhythm and blues—the early beginnings that started a revolution.

During this early adolescent time, my trusty mode of transportation was a maroon and cream Schwinn bicycle, a highly prized collectible in its own right today. I didn't have the fancy model with all the doodads. In fact, I abhorred the upscale bikes, they seemed so prissy and precious. I felt it necessary to reduce my bike to basics, and this was done simply by removing the fenders. My

parents were annoyed at this destruction. I believe they were afraid that this fenderless bicycle was not representative of the "responsible" son they were happily raising. I think they feared that this hot-rod attitude would lead to a desire for a motor-scooter (it did) and then a motorcycle (it didn't). I had neither.

One of the first places the bike took me (beside visiting friends, traveling to and from school, and trips to the corner drugstore) was back to the park where the bus stopped. A few years had passed; progress had come to the Atlanta transit system. We had trackless trolleys, larger and quieter, but with the same transfers that I used to collect.

The mobility of the bike offered me other opportunities. I loved to wander through neigh-

borhoods, get a feel of the streets, view the houses and get a glimpse of the overall topography. In a way I was acting out being an archaeologist on a dig, but I wasn't quite sure what the quest was all about. One day, however, I discovered an old car, a 1926 Buick sedan, quietly at rest, parked in

front of a house of equal vintage. The feeling was like being thrown into a time warp, although before *The Twilight Zone* we didn't know about such concepts.

It was then that my love of old cars developed. Looking at pictures of vintage automobiles reproduced in books and magazines had a flat, removed, and cold reality. Seeing a real time-worn auto in context was a thrill. This was an original car, no slick restoration. It had an attitude, and a haunting mystery. Added to the sudden sense of discovery, the entire process was unique for me, and enormously exhilarating. Another beginning.

A return trip was necessary to see this oh so humble, boxy Buick. This time I brought my equally humble "Baby Brownie," yesterday's equivalent of today's point-and-shoot camera. The classic Baby Brownie used 127 film and got twelve shots to the roll. There was no one-hour photo return then. It took a week. For me, the anticipation of waiting for my prints was just like waiting for the pictures of aircraft. When the pics came, they were inside a folder with a bright, Kodak yellow cover.

I continued bicycling through neighborhoods, wandering and wondering when a new discovery would appear. Was I looking for fossils, a hidden treasure, or a buried temple in another life? It was the same spirit and energy of the archaeologist that brought me to these old autos. My eyes were fresh, my body alert as I darted steadfastly about, always on the lookout.

As with the aircraft photos, I began collecting car pictures. I loved their "snapshot" look, the lack of formality, the odd light sources, the honest no-nonsense attitude. (I still collect these photos today.) My own ability to make pictures was limited; my neighborhood sources were drying up and I wouldn't be driving a car for a couple more years. So, I began to acquire snapshots from other car lovers, and from aficionados who were attempting to sell their cars. They either gave away their pictures or sold them for fifty cents or a dollar.

To collect these pictures I formed a simple and fun plan, and went on the quest this time through the classified ads of *The New York Times*. My dad would bring home the Sunday edition. This newspaper was another visual event for me, but I compulsively went straight to the classified section that listed antique and classic autos for sale. Reading the list was exciting, looking at the names of the cars and wondering who was behind the ad, and why they wanted to sell such a fine piece of machinery.

Whenever there was an indication that a photograph was available, I would write to the individual for the photo, never mentioning any intent to purchase the car. My taste leaned toward pre-war Rolls Royce, Bentley, Cadillac, Duesenberg, Lincoln, Cord, and Packard. I got photos galore, and, yes, I still have them.

My letters were very businesslike in form, content, and appearance, something my dad briefed me on to get positive results. Occasionally I would get calls from these sellers. They would track me down, calling the Atlanta telephone company for information. They were dismayed when I spoke to them in a high-pitched, pre-puberty voice. "I'd like to speak to Mr. Baeder about his interest in my 1928 Rolls." "I'm John Baeder, I wrote you the letter." "You're John

Baeder? You sound awfully young to be wanting to buy an old Rolls!" There would be a miffed silence and a definite tone of bewilderment. "Well, I love the cars and just wanted a picture or two for my photo collection. Do you have more available?" I could sense their amusement and almost see their smiles; these guys knew they had a passionate, old-car nut on the line.

To investigate the origins of another early passion of mine we need to fade to a boy with tousled curly hair, a roving eye, and the wish to accompany his mom to the grocery store. These were pleasant jaunts to neighborhood establishments. Among others, we would visit Otis Johnson, who shared the front of his meat market with Mr. DeWald, the produce man with his great grin and chin.

I loved to watch Otis cut, chop, and saw. It was the actions I enjoyed, not the brutal assault.

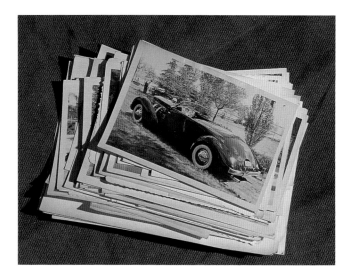

Better was seeing the wrapping of the meat in the white paper and brown tape. I loved to watch him fold the paper over one side, then the other, then fold over the meat in the paper. The pull of the tape. This was dance. I'd go home and find anything that was wrappable, get some old newspaper and some tape, and emulate Otis Johnson, the butcher.

More than watching or emulating Otis Johnson, however, it was Mr. DeWald's and other grocers' display signs that appealed to my constantly gazing, curious eyes. These signs had a method and style of lettering that I found amusing. The numbers were large, bulbous, flowing forms connected with thin lines. (Typography fans may recognize this as reminiscent of Bodoni, but Bodoni gone crazy.) The numbers had an Ultra Bodoni Bold spirit, but the particular rhythm of the forms

came from the sign painter's brush.

These observations of mine became more and more perplexing later on as I noticed grocer signs in other parts of the country. The mystery had to do with their sameness. There was an amazing commonality in the letterforms. Were these signs made by a national sign maker? Or were they executed by each store owner? And did all these people go to the same sign-making school?

This singular and similar quality of grocer number forms is odd. I became more aware of the phenomenon as time wore on and I traveled. Even in Europe, I would notice these grocer signs, and they always brought me back to Johnson's meat market and DeWald's produce baskets of my childhood.

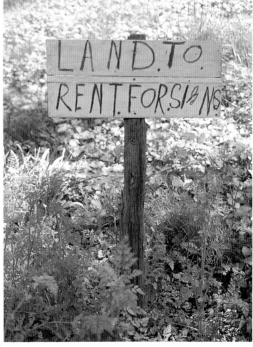

These signs were the start of my passion for and study of letterforms. More importantly, I fell in love with the personal, informal, untrained, honest, and above all, anonymous signs that people paint to express a need, a desire to communicate. By doing so, they ignite sparks that form visual poetry, an expressive language of and from the street.

In addition to these hand-painted signs, I was also mesmerized by the slick professional signs, the horizontal and vertical strokes of the painter's hand, the sweeping curves and shadows. I enjoyed studying italic script lettering and how the artist's brush joined each letterform. Above all, I always knew when there was a good artist behind the sign. Of course, the more complicated the sign, the more enjoyment I got from it. A particular mark of skill was to be found in the corners of letters: corners were sometimes done with a certain finesse and panache that few lettering artists had. The best painters squared the letterform, whether it was a serif or a straight gothic letter, with a little hit of the brush to give it a sharp, crisp corner. Oh, I loved that effect. It made me happy,

although how it was really done was a deep mystery to me. Old, faded signs with their faded paint gave me a great deal of information on the stroke handling. And what a big difference there was between an old painted sign and those hand-lettered grocer signs that were done in the flash of a moment, with the same basic intentions but executed with a different direction and need.

I was compelled to know the sign painter's secret; I had to find out for myself. At the time, I was in the ninth grade and because of my interest in art I was often called on to make signs for this or that event. But I never liked my signs because they didn't have the right look. So I bought a set of professional lettering brushes and taught myself those sharp corners. (Was I on my way to becoming a sign painter? I actually applied for a summer job at Atlanta's best sign shop, "Chubby" Dietz, but I was turned away for lack of experience.) All the kids were envious of how I got my signs to look better than theirs. When I showed them my secret they were amazed that I could buy a brush that would enable me to paint a letter better.

I want to put the forthcoming photographs into historical perspective. Reflecting back, my collecting of them appears to be very romantic in nature. At the time I began gathering them, however, I felt that I was just doing my job, being a professional. I was my own committee, the street was my office, and the expressions on the street were my easel, my drawing board, another world that welcomed me. (Also, it was a relief from the daily hum-drum of office activity in the nervous ad world. The sense of discovery was much more fun.) I was young and felt absolutely no concern for the future, that bizarre word.

Making the photographs and photography per se were not a priority for me. As an involved onlooker, capturing and documenting these written words and their artfulness was far more important. I had no philosophical, intellectual, or emotional quest as a foundation; I simply loved

the signs whenever or wherever they appeared in front of me.

The time and place I began to collect these pictures is of the essence. Though I was not conscious of it, I was in a place that provided a fertile ground for this beginning—a major southern city. It happened naturally, being in an opportune environment that provided a catalyst. Ten years later in Atlanta, it wouldn't have happened. Ten years earlier, I wasn't ready, although *then*, I am sure that more material would have been available.

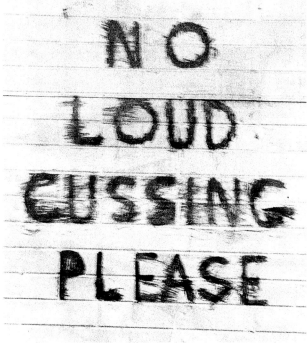

In the past, acquiring a sign was sometimes a task, but always an adventure. One day while driving around a neighborhood that was close to where I lived in Connecticut, I came across the sign, "Land to rent for signs." The purity of that message alone was enough for me. As I recall, there wasn't any land, it was a front yard. The sign was made from what seemed to be a piece of orange crate attached to a length of tree branch. I waited until dark, returned to the "land," and simply borrowed the sign for an indefinite period of time.

The sign grew on me for a couple of reasons, apart from its direct message and its construction. The use of script in the word "sign" breaks me up. It makes me smile, the way the script is all lost in the wonder of spaced-out capital letters. There is an innocence and sweetness of character expressed here. Charming, quirky, funny looking signs are so engaging that they seem to exist only to themselves. But people have been making such signs to communicate ideas and feelings for centuries. Those messengers send their messages out in forms that resemble a breeze, a smile, falling leaves, or subtle fragrances. They move one to want to embrace and cheer life itself.

Numbers of people have been important to me in my quest to learn "sign language." One of my earliest mentors and supports in Atlanta while I was an art director was Sol Malkoff, a kind, soft-spoken gentleman who was the typographic king of the city. Sol managed the most professional and respected type house in Atlanta, and he had followed my career steadfastly. Sol was the first to recognize my interests outside the ad business, my interest in the *everyday* in reference to letterforms and how they affect our way of life.

I would frequent Sol's home and enjoy lovingly cooked dinners by chief chef and dear wife, Sadie. The conversation was always intense, with expected *type* talk at the table, combined with everyday politics and art. After dinner came the best dessert, which I always relished and eagerly awaited—time spent in Sol's vast library of books on design and typography. This was an additional feast for a full belly that was getting fuller with intellectual and spiritual nourishment. Thanks to his giant generosity, Sol would lend me books and periodicals, knowing that I would devour them and eventually search and locate the same for my own growing collection.

One of the most influential periodicals that spoke to me was *Typographica*, an English magazine edited by Herbert Spencer, who, at that time, was England's supreme master, a living legend, and a widely published author on type and typographic design. Spencer was the kingpin in the type world in England and the continent. He also took magnificent photographs of street signs painted by anonymous people, along with other brilliant observations on professionally made signage in London, throughout England, and elsewhere on the continent.

I began subscribing to Spencer's periodical, eagerly awaiting each issue with the same enthusiasm I had for my aviation, science, and mechanics magazines when I was younger. This time the expectation was more serious and important. In each issue Spencer would feature an article written and illustrated by himself, and include articles by other designers who were also involved with

type and signage of the streets, always with important relevance to design and communication and its application either to the personal or commercial world. I came to feel that these contributors, despite their high stature in the graphic design world, were kindred spirits, soul mates. Although I was still searching, I realized that we shared a common belief system, one that inspired me and validated my sense of being part of a narrow group that thought and felt alike.

Amazing how memory fades and can be brought back and focused. Recently, Sol Malkoff reminded me of an article he had written for the October 1962 issue of *Atlanta* magazine. The issue was devoted to the graphic arts industry in the city. My sign photos accompanied the article, which was titled "The Poor American Handwriting." It dealt with a major issue: the incompatibility of the English language with the improper workings of the Roman alphabet. This rhetoric was a scholarly delight and, perhaps not above most heads of the crowd in Atlanta who read *Atlanta*. Sol was a catalyst, educator, and communicator extraordinaire.

Thank you, Sol. You helped lead the way. I am grateful for your essence and affection.

In my ongoing study of "Sign Language," an important book was Lee Boltin's *Jail Keys Made Here*—which is today an underground classic and a collectible. Lee was a photographer who had worked for the American Museum of Natural History in New York, and was a specialist in photographing art, everything from Tutankhamun's gold to Henry Moore sculpture. Precious objects were his subjects. He was a master of the still life and a brilliant lighting technician. A warm, witty, outgoing man, he could charm anyone, from the stuffed-shirt crowd to the cafeteria crew. And he loved, photographed, and collected handmade street signs.

In forming my collection of sign language for publication, I didn't want to copy or emulate Lee: he was the first to publish a large collection of street signs. But his interest was mainly in their

quirky humor and touching idiosyncrasy. My point of view was different. I wanted to evaluate the signs as a folk art idiom; after all, it is art from the folk. And it is fascinating that homemade signs are often more effective than the sophisticated media to which we are accustomed. Professional communicators (and artists) take themselves so seriously that they sometimes fail to speak to their audiences, they talk to each other instead. These naive signs have a power and dignity all their own, and even though the original intent sometimes is obscured, the sincerity is evident. Their modesty, pride, and even vision help redefine these signs and place them in a folk art context.

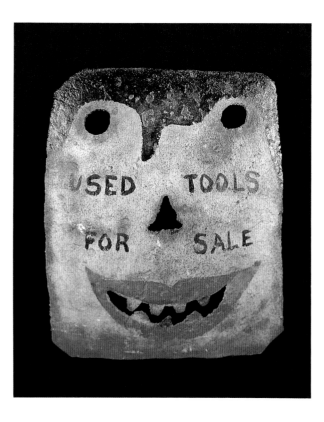

I purchased the "Used Tools For Sale" sign from Robert Reeves in Atlanta. Not only is Robert a supreme dealer in American folk painting and artifacts, he's a kind soul and a lover of the anonymous painted sign.

One glistening fall day I walked into Robert's home, which is also his gallery. Sitting by the door was this sign. I got so excited that I felt it would take an injection of Valium to settle me. Instead, I calmly got a glass of water and sat down to regain my composure. The sign was approximately 25 by 21 inches, and seemed to be made from ⅛ inch boiler plate steel. It weighed about twenty pounds. Robert explained that he'd had the sign for a while but had never put it out for sale. He knew that I was coming over, and had placed the sign in this strategic position. He knew that I would also get excited upon seeing it as I entered. Needless to say, I bought both signs.

Robert frequently sent me photographs of signs that he had seen during his many travels looking for folk art. They always looked like pictures I had taken. Robert's friendship has been like having a twin brother, a clone, a carbon copy of myself. Thrilling are the journeys we take together

driving around neighborhoods in Atlanta, reliving my old days, feeling like a living ghost coming alive, twisting time backwards.

Several months after my move to New York City (the silly Big Apple slogan did not exist then, but multi-colored cabs did) and getting settled, I called one of my first real close friends and comrades-in-spirit, Ken Kneitel. Ken and I came from totally different backgrounds but we were, you might say, from the "same egg," which is something to behold. Ken was my first kindred spirit in my new life in the metropolis.

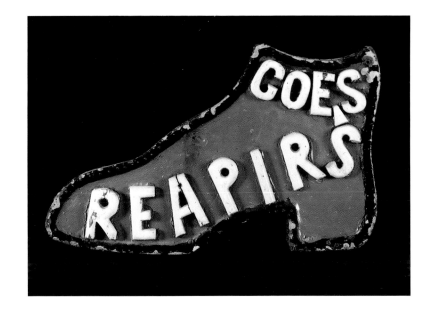

One Saturday afternoon, after taking one of our antique treks to New Jersey, we ended up at Ken's flat, a walk-up apartment in an old tenement building on East 32nd Street, with a tub in the kitchen, and a toilet in the hall that was shared with the other tenants on the floor. Ken made coffee and toasted English muffins. We sat down for our usual chit-chat, recounting the day's finds. I expressed interest in all his stuff. There was a mutual kinship, a beautiful connection with visual ideas, combined with the distinctive links with those keen interests and ideas that were part of our separate biographies. Ken knew my passion for the handmade sign. We talked about my Atlanta finds and how I always carried a camera on travels just in case that magic moment would appear before me. And it did, on Ken's wall.

On the wall was an old, handmade, shoe repair sign: "GOES REAPIRS." I marveled at it. Ken knew my passion for homemade signage, and at the moment I expressed to him how much I loved it, he immediately said, "I want you to have it. It's yours. It's worth more to you than me."

Some signs are pure entertainment for me. They are like jazz in its most basic forms. Rhythmic, harmonic, and melodic ideas are the ingredients and essentials of jazz—music of the streets. In signs, this quality can come from words, thoughts, or a curl of the brush.

During sojourns on inner city streets—combing the underbelly of neighborhoods—or on country roads I sometimes see signs that I think of as Charlie Parkers. Parker, of course, was the grand master of improvisation, the giant influence, the pivotal force in jazz and be-bop during the golden years of the late 1940s and early '50s.

So how does this idea and observation apply to simple signage? When a sign transforms itself to another level, something more than it was intended to be, and when there is an improvisational quality inherent in the total expression, an additional element that pushes a preconceived thought or idea—that sign is a Charlie Parker.

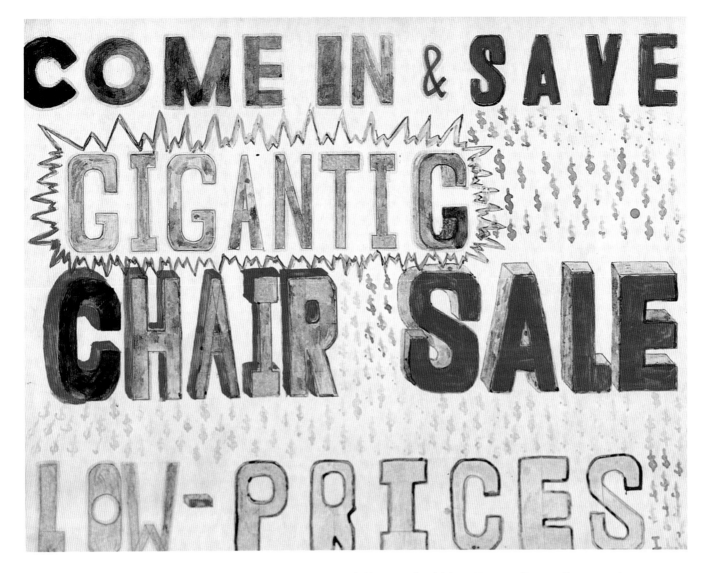

I sometimes see signs that I must have. The first thing I do is to ask whether I may buy it. This sign was in a store in Harlem. The owner thought I was nuts, and then asked me if I was in the business. I told of my interest in handmade signs, offered him five dollars, and told him I would paint a new sign.

As I waited, the man thought, apparently dumbfounded.

"Ten dollars," I said.

Pause. Pause again.

"Five dollars. Take it, it's yours, whatever ya wanna do with it. I make me another one."

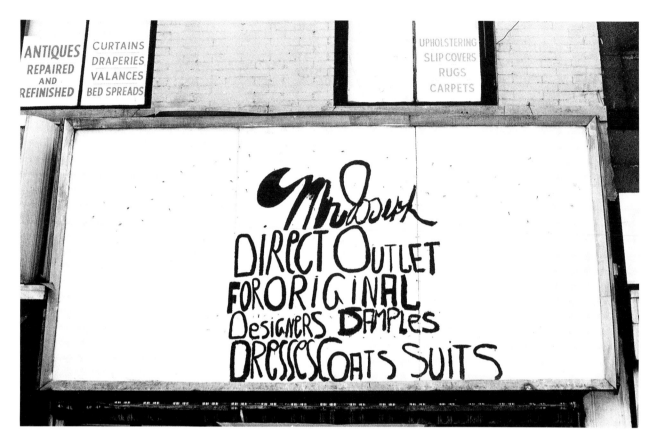

ANTIQUES
REPAIRED AND REFINISHED

CURTAINS
DRAPERIES
VALANCES
BED SPREADS

UPHOLSTERING
SLIP COVERS
RUGS
CARPETS

This sign was obviously done from a ladder, an ambitious sign that began with a sweep and gutsy whoosh of the brush. I believe that the ladder wobbled, and the hand did too. Whoever was on the ladder knew well that they could only work at arm's length and width to create the sign. The flush left lining up affirms this knowledge. But the sign sits in space with style and grace. Notice that the "S" in "Samples" started out as a "D"; also notice the inconsistent use of upper and lower case "E."

One Sunday, in Memphis, Tennessee, I got lost looking for an amazing gem of a sign, a rusted pig. In my search, this gentleman appeared. He was writing the music of the streets. Unfortunately, I couldn't wait to see how his beginning turned out. But I asked him directions to the pig, which he knew, and I found it.

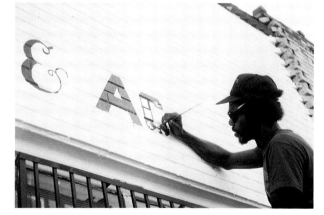

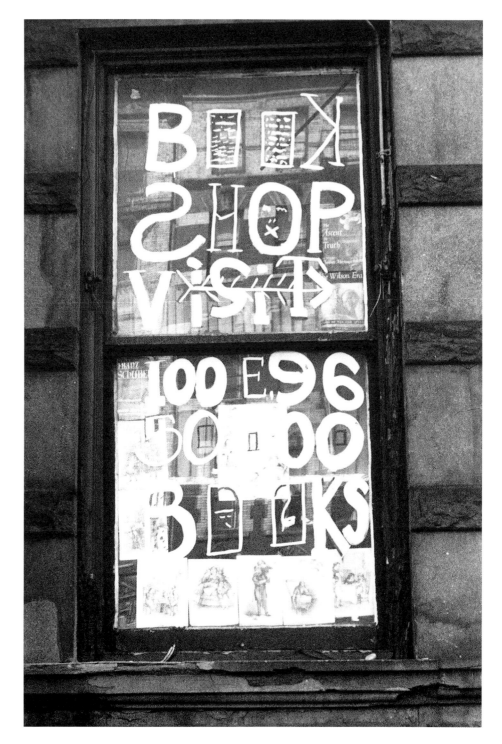

Old books are a habit with me. I love the perfume of old bookstores. Their keepers are often characters, bent over a mess of books and papers, and frequently covered in cigarette ash.

"Book Shop Visit" was never visited by me, although it was two blocks away from where I lived on East 94th Street in Manhattan. It's strange that I made not one visit, but I feared that I'd get caught in the stacks and move in with those 50,000 books; all new friends, all that perfume.

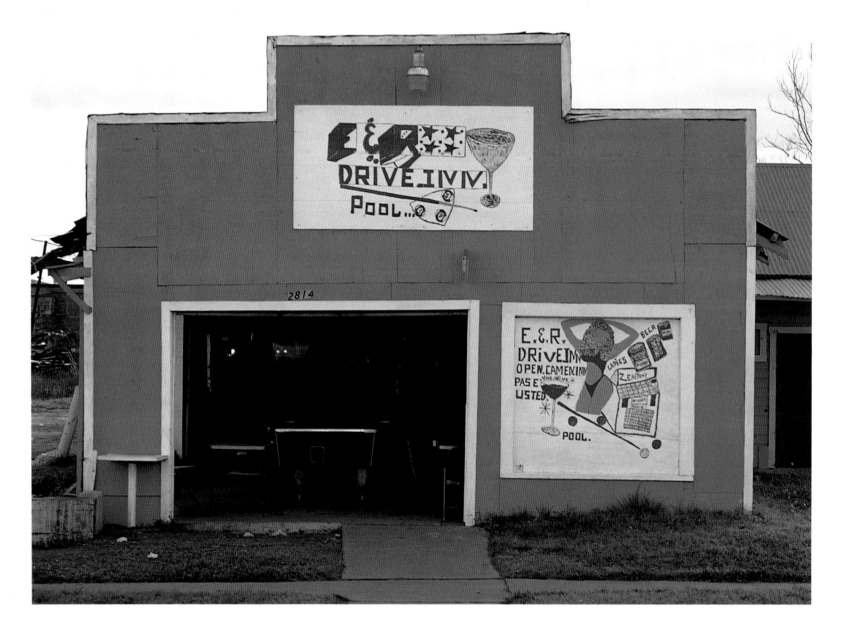

Believe it or not, the "E and R" is a drive-in pool parlor in Houston, Texas. The door to the left is where you drive in, plant your pickup, chalk up your cue stick, and get cookin' with a game of eight-ball.

The lower right sign was astonishingly attractive. I felt an immediate need to own it. How nice it would be gracing a wall.

30

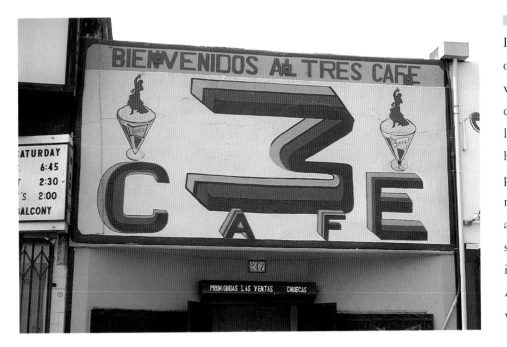

What a wild "3." Its dominance is overwhelming, along with the double shadow colors on the "Cafe" letterforms. This must have been some snazzy party place inside. I was not welcome, however, as was obvious from the stares I got on the street in downtown Los Angeles. Three what? I wish I knew.

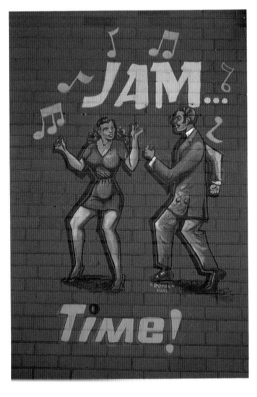

Music and dance in Atlanta.

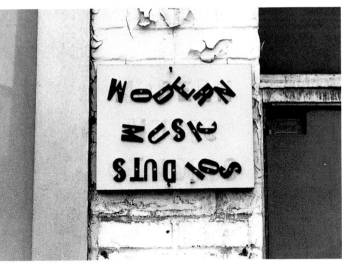

If the same letterforms that spell "Modern Music Studio" came loose and began falling in place, they would sound like a musical version of the words. You don't have to look too hard to hear the melody, catch the little riffs. Appropriately, the sign was in New Orleans.

Forty-second Street in Manhattan has been the iconographic capital for American raunch. The street makes a freak show look like a baby shower. It used to be filled with vaudeville houses that gave way to burlesque houses that gave way to sleazy film houses. The legitimate Broadway theaters and new ugly office buildings block further rampage. But, dark as it is, the street has its lighter moments. All the characters that spring up from the cracks are not drug-taking, pimp-loving pickpockets. There are some serious suckers who are trying to make a buck using available talent. Some are artists who can't make it anywhere, but try, with crayon in hand and hope in their hearts.

How many times have you seen a word written to look like what it means?

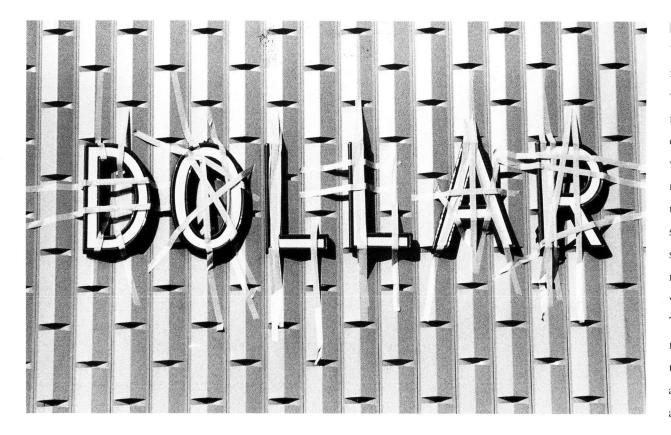

The owner of "Dollar," an updated five and ten cent store, was not sure that the newly bought commercial letters would hold on the newly installed textured facade. The superglue from the store shelves may be not so super. So tape was used for security. The unique taping method, overlapping the letters, gives them a primitive and fragile appearance.

This is my painting of the Good Food Diner, completed in the summer of 1979, shortly after my visit to the diner itself, a dream come true. The painting combines two major passions, my love for diners (and for painting them) and my love for anonymous hand-painted signs.

An itinerant sign painter from Alabama traveled to the diner every year, repainting the menu and prices. He was actually on the premises when I was there. I couldn't find him, but I discovered his car and trailer parked out back.

The diner is in Front Royal, Virginia. If you're nearby, and curious, you may want to take a look at the new menu and new prices.

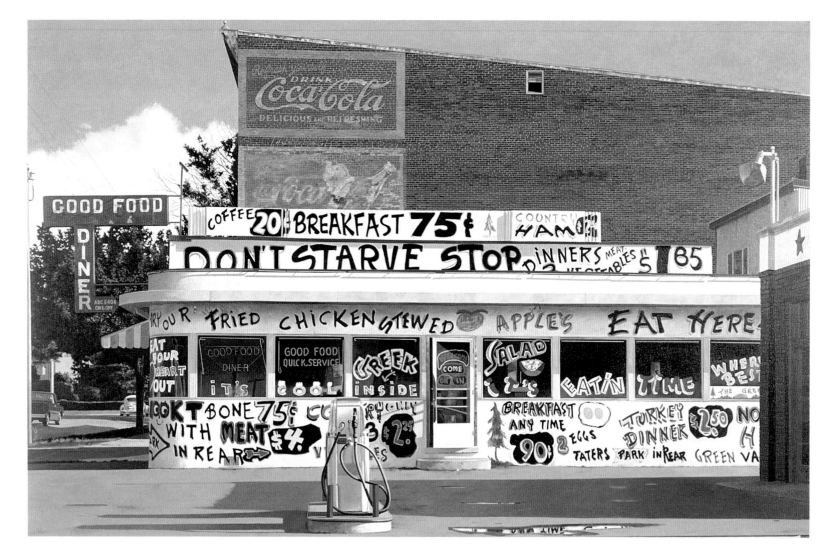

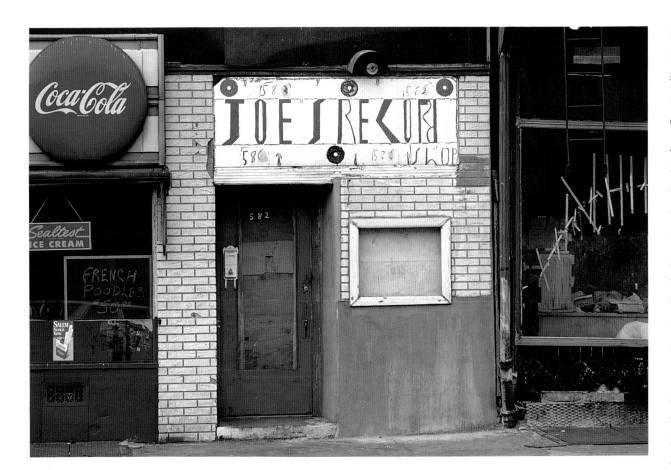

This sign was in Brooklyn, New York, in a "questionable" neighborhood. On a Christmas Day. What a gift. Hot records? Who knows? But Joe, or whoever he contracted to paint the sign, tickles me more than pink. I don't believe the writer was trying to be wacky. The brushwork is purely improvised: the bold and unfinished "J" and "S," and the planned "O"s and consistent "E"s make a strong contrast to the extreme "C" and the wilder second "R" combined with the feeble lower case "D." Weird music. The quiet afterthought of "Shop" and the almost illegible address are soft notes. The red, blue, and black records punctuate an impressive finale.

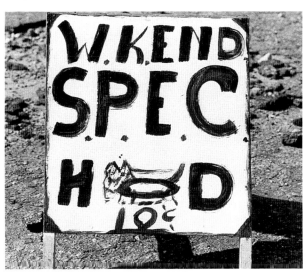

The sign is from Abbreviationland, Georgia, circa 1962. Musical beats (boom-diddy-boom-boom, bah-boo-dah) created by punctuation. For those who perceive this improvisation slowed down and dissected, it reads: "Weekend Special, Hot Dog 10 cents." Can't be too hot for 10 cents; even over thirty years ago they cost about a quarter.

Care about what? It doesn't matter. Examine the word "Carefull." It means "full of care." This person has a lot of responsibility and wants to share it. Examine the word "responsibility," turn it around: the ability to respond. I believe this sign is loaded with concern and love.

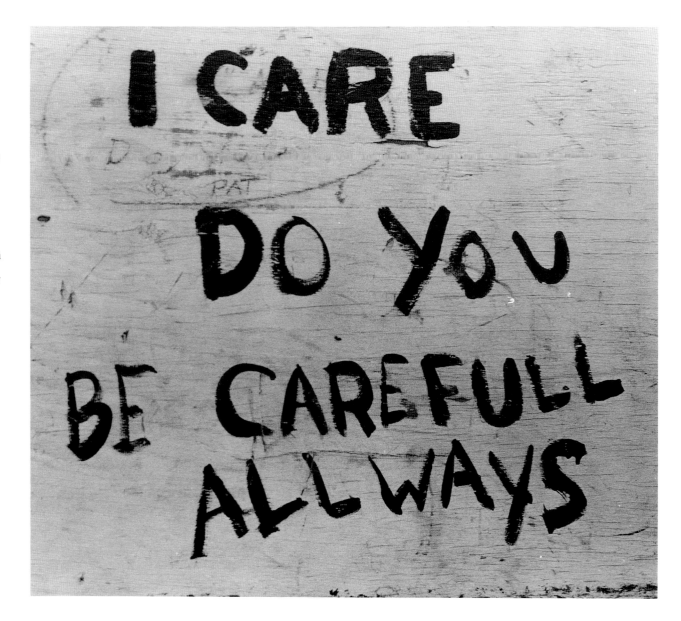

Love. Hate. Confusion. Politics. Sexism. Pride.

Deeply felt emotions, nobly expressed, with brush at hand or another available tool. We witness, observe, engage, and become, for the slightest moment in time, part of someone else's life. Fleeting feelings fly into our world. We decide to let them sink or swim in our consciousness.

This signage can last in time and place, or, with a blink it may disappear—washed away, torn away, replaced by a fresh face, a new place. One wonders, wanders, and waits for another heart to open wide and deep and spell out what's going on in the soul, adding poetry and dignity to our blessed language.

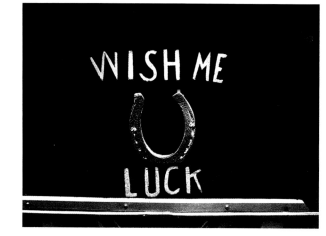

An assertive statement: an actual horseshoe nailed to a fender skirt above a rear wheel on a car in Atlanta. I don't recall if there were rabbit's feet hanging from the inside mirror.

Someone had a change of mind, but it appears from the attempted erasure that they weren't too sure about their emotions.

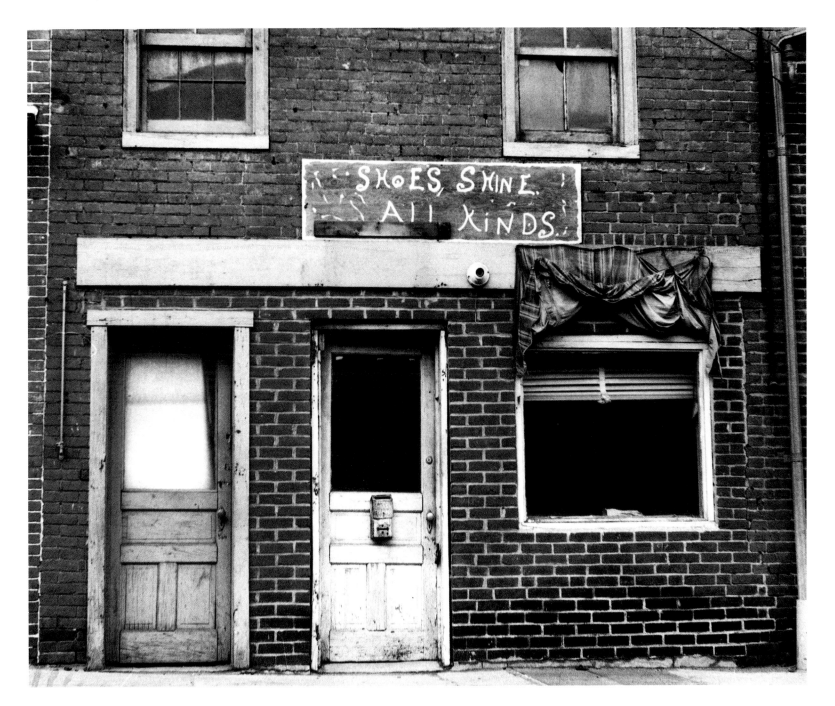

▲ This shine man is a
perfect egalitarian.

▼ This shine man has really arrived: he owns a refurbished gas station on a major thoroughfare in St. Louis.

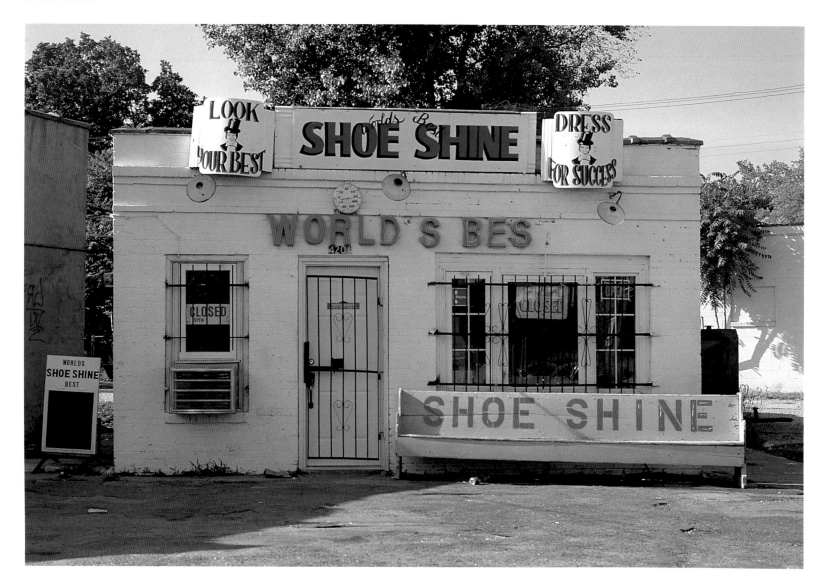

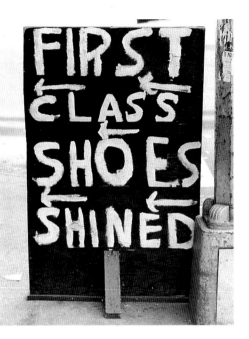

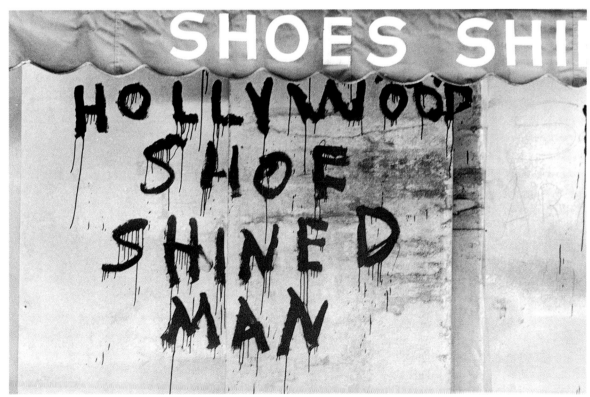

Shoeshine culture has its share of caring. The communication of this sign does not mean that only Gucci, Bally, or Church's shoes are shined. It does mean that the reader will get a first-class shine. Just follow the arrows.

This shine man is more subtle with his "first class" metaphor. He decided to use Hollywood as the symbol for quality.

'Nuff said.

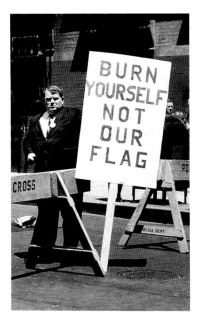

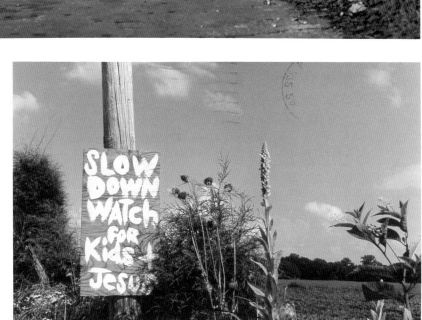

▲ This irate sign bearer demonstrated during a parade in upper Manhattan in the dark days of the Vietnam War.

▲ This sign was found in Houston, Texas. Most Texans believe that their state is the only one in the United States. I believe this sign writer had never left Texas—or Houston, for that matter.

▶ Good advice at any time.

This temporary wall was found on an approach to the East River, the FDR Drive in Manhattan. The structure cried out for an important message to be painted on it. The time was the late 1960s, when the Vietnam War was dividing the country.

This powerful sign no doubt addressed President Johnson and Washington policy makers. The message is broad and bold and leaves to one's imagination all other political figures, national or local, who were opposed to any kind of change. Nothing new.

At least the sign writer was fair, letting us know that there are some honest politicians. Where are they?

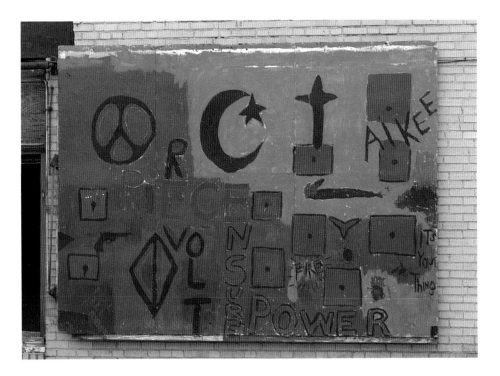

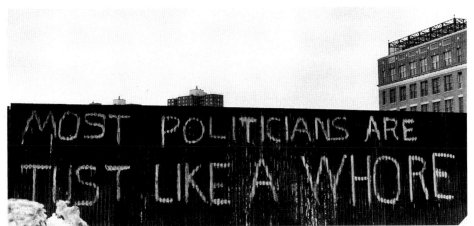

The cult, religion, or organization that was responsible for this engaging sign is possibly of African descent. It was found in the south end of Boston in the late 1960s, which is evident from the powerful statement and softened peace symbol. The use of "crossword" style lettering enhances the statement, although misspelling weakens the message. The ten red squares with carefully placed dots are a mystery. The other symbols can be recognized. But the large signature, with the "Its your thing" message, combined with the tiny revolver, are subtle hints of further cryptic messages.

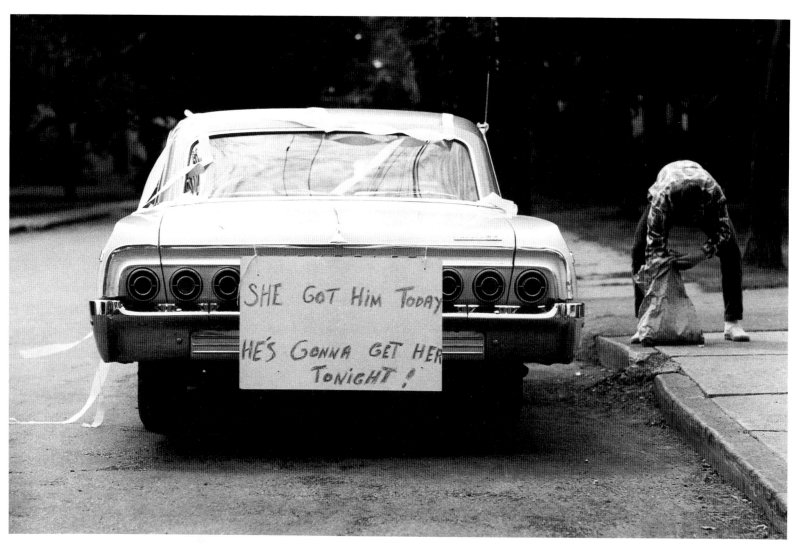

Before male chauvinism became a phrase in the American lexicon, these pictures were snapped.

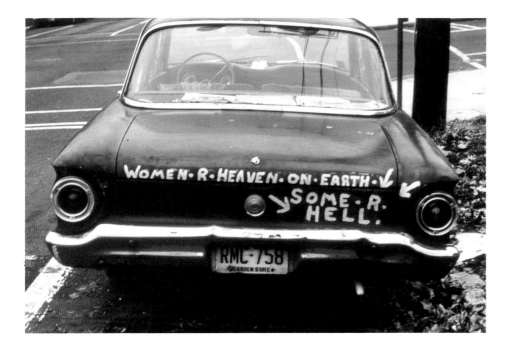

There are those who know exactly who they are and what they are about and have the expressive need to tell everyone these things.

In segments of black male culture the automobile represents and symbolizes a deep level of freedom. This freedom translates into a visual vernacular and verbal jargon. On a more subtle level is the use of the slang word "wheels." Wheels become the center of attention to express this freedom, self-esteem, and individuality. "Wild Cat" wheels are painted red, a perfect example of displaying prominence. ("I'm a wild cat, man, look at my wheels...") A few years ago very wide whitewall tires (reminiscent of 1940s and '50s whitewalls) were the rage. More recently, they had to be combined with magnesium rims for the complete new "wheel" look. Today the new rage for "wheel attention" is the use of gold anodized spoke wire wheels with color knock-off spinners. This is the total hip wheel attention for wild cats.

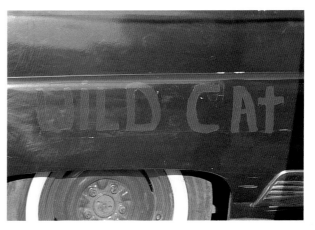

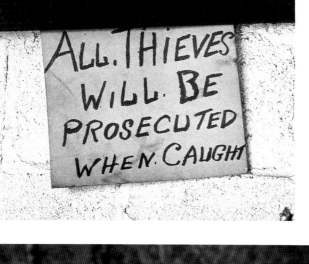

A junk store somewhere in Cleveland, Ohio, had this sign up front above the register. I asked the owner exactly how they prosecuted the thieves after they were caught. He just nodded at me and looked away.

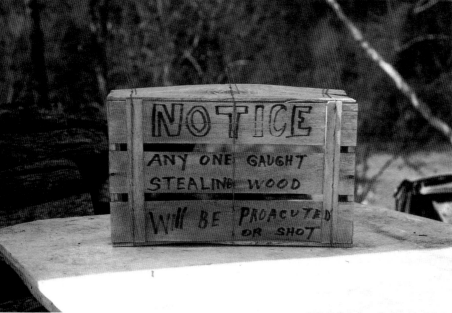

I had one of the most astounding sliced Bar-B-Que pork sandwiches served from an old trailer on a road between Kingsport and Johnson City, Tennessee. This sign appeared next to the trailer. The author should be prosecuted for his misspelling, although no doubt the wood was precious hickory logs used in the grill. I love when people take the law into their own hands through a simple sign.

Another artifact of the Vietnam War was snapped around Los Angeles in 1968. Steve, where are you today?

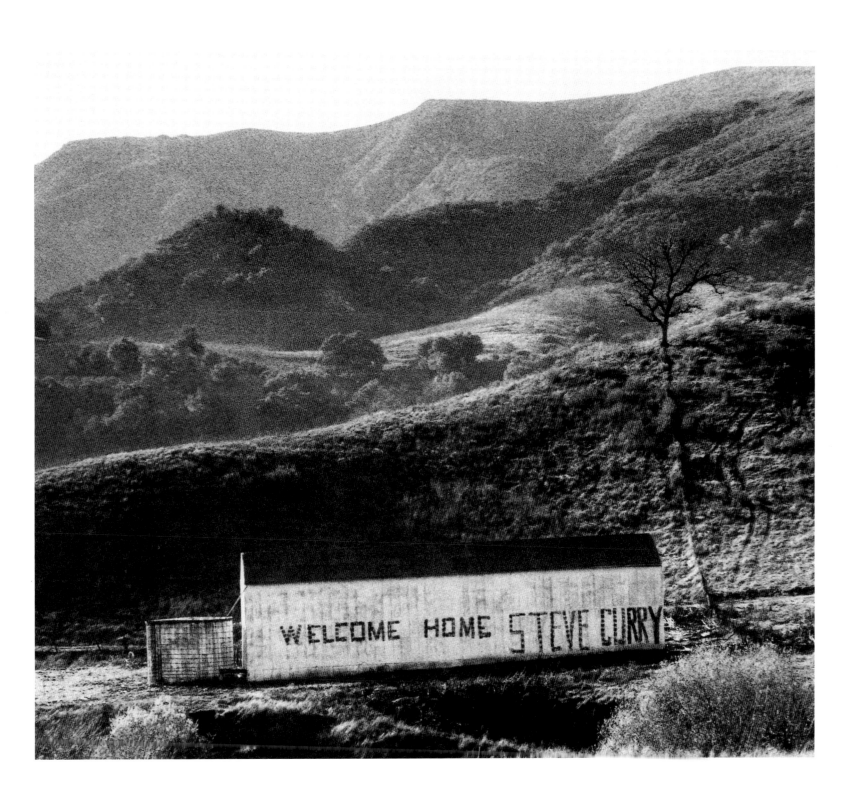

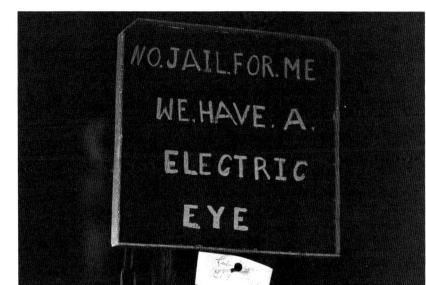

The sign is nothing but a scare tactic and is utterly confusing. It was photographed at a flea market in New Jersey. Obviously there was no electric eye, except perhaps an extension of the owner's paranoia.

This hopeful sign has many replicas in many places, although I've never seen one at the base of a tree.

This bedraggled garbage can has seen better days. Is "Smart" the name of a business? The owner's name? Or just an expressive word with hidden meaning? Perhaps the writer was an individual with shortcomings, feelings of inadequacy. The letters of the word cry out for attention. I never investigated what was on the other side.

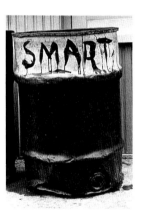

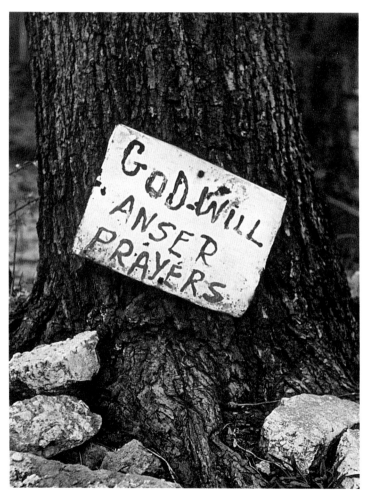

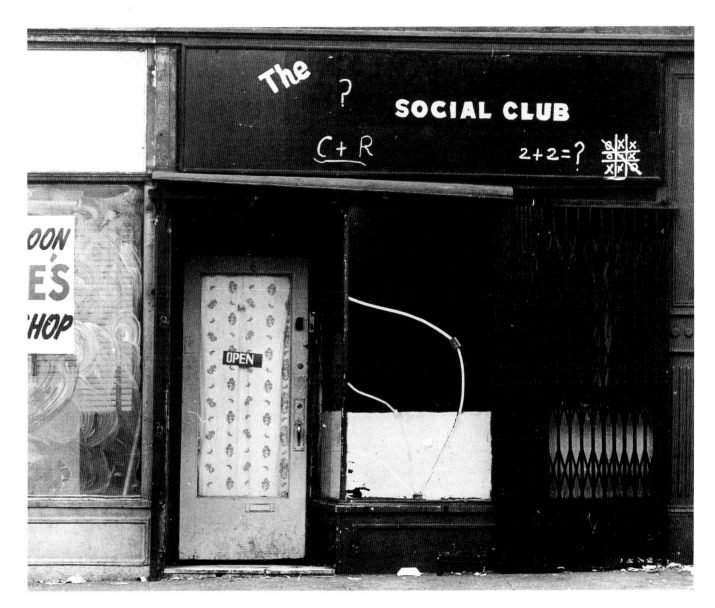

We all have self-doubt in varying degrees. Most of us don't admit it. The sign writers in the picture here and those on the following pages did. Or did they? Were they trying to get our attention by using the question mark? What were they questioning? We'll never know the answers. Is the question the answer?

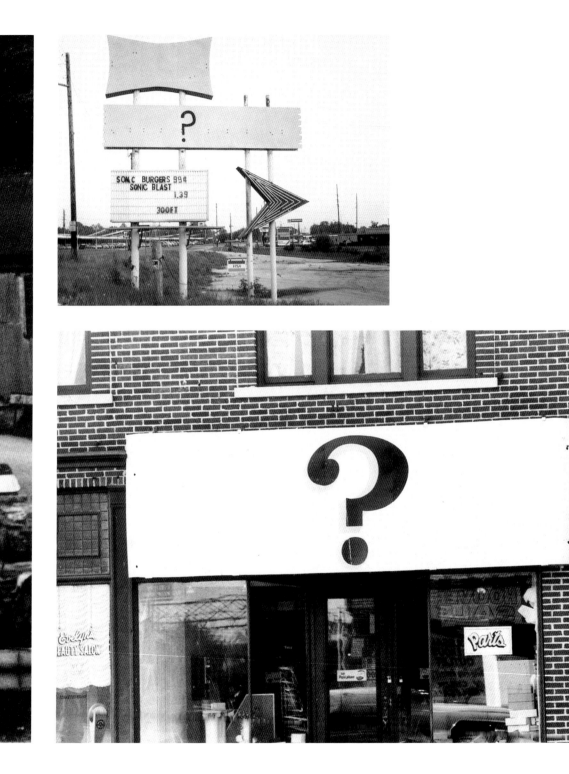

There is something appealing, arousing, and arresting about sign painters who make words, thoughts, ideas—even simple proclamations—into specific shapes and use space creatively. In most instances they do so unconsciously. Often, they reveal a visual audacity that turns itself into playful inventiveness. This makes me take a second look, ignites my awareness, and awakens my spirit. The lack of formal training of these painters qualifies them as folk artists, but I do not wish to emphasize this concept. Rather, I'd like to bring to focus the pure execution of a thought process combined with the need to convey information in a relevant manner: in specific shapes, sizes, and spaces.

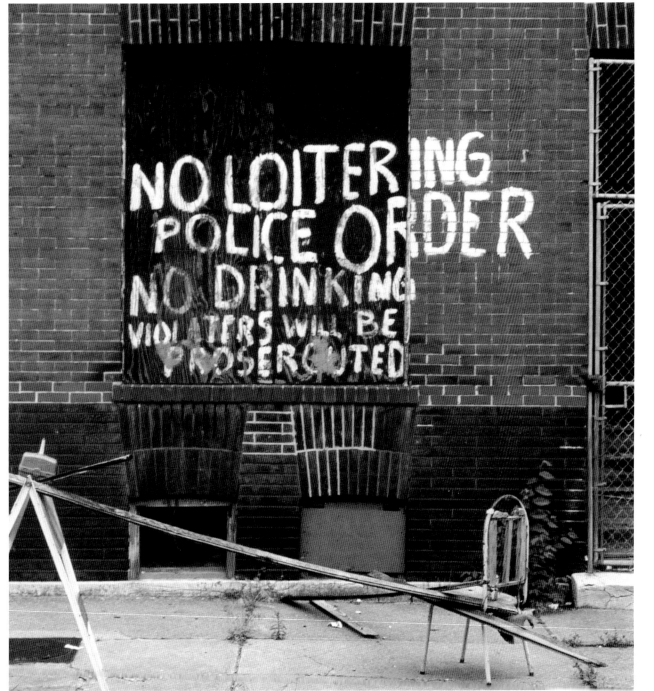

This sign in St. Louis, Missouri, is a fine example of accepting a boundary (the boarded window) and then going outside it for emphasis and drama. The abrupt change of texture and color heightens the message. Here, too, the consistent capital letters and tight word and letter spacing display a worthy importance and fortitude.

It appears that two people were involved with this unique sign found in upstate New York. (Perhaps one person with a mood swing.) The clapboard acts like ruled paper for penmanship. The extremely thick and thin forms allow the reader to fill in the complete letter for readability.

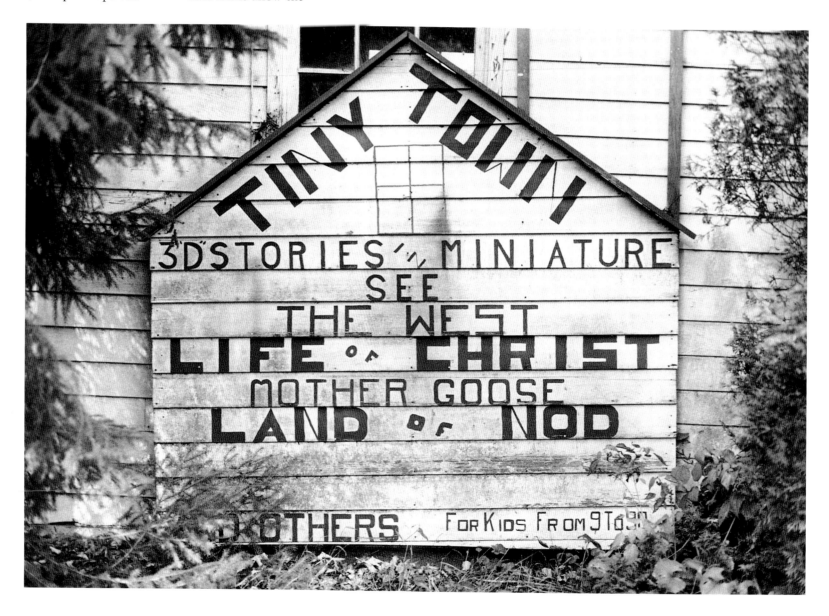

54

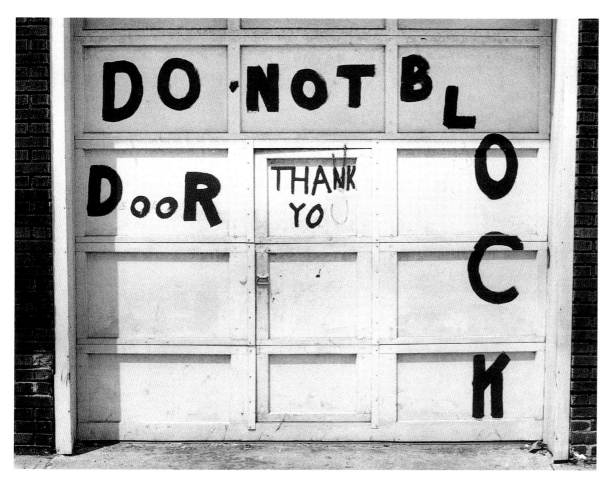

The person who painted this garage door must be related to the one who did "Broadloom" and "Dudley's Record and Donut Shop." Did he run out of paint with the "U"?

Here's the ubiquitous tire sign, sans tire. You've seen used tire joints all over, often with signs made of discarded tires. Here, however, the circular tire motif is on a piece of metal wired to wood; a typical recycle, although we have no idea where it was recycled from. The two notches on the upper inside circle provide no clue. What matters most here is the affirmation "Yes," the instruction "Look," the result "Bargain," and directional arrows toward the stock of tires.

This sign person had some training in painting letterforms with a brush. On the day this sign was done, however, there may have been a bit of tippling. The painter started out with a wallop: a powerful "D" packed with paint. Then I believe confusion set in. It is perfectly obvious that the painter started out with no clue about the space to be covered: this seems true in most of the signs I am attracted to.

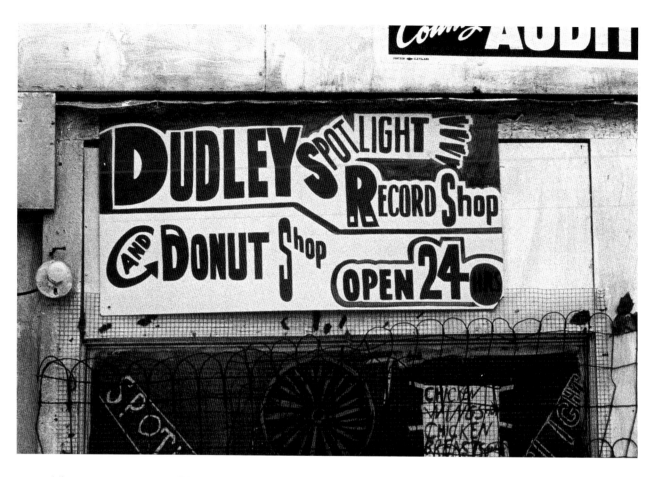

The sign writer realized that once the "L" was in place, there had to be a deft solution. The result is pure whimsy.

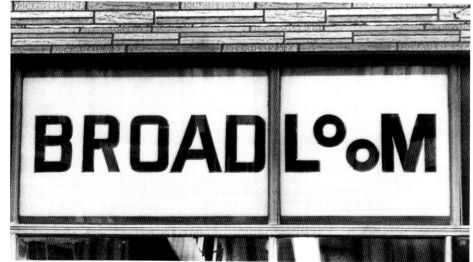

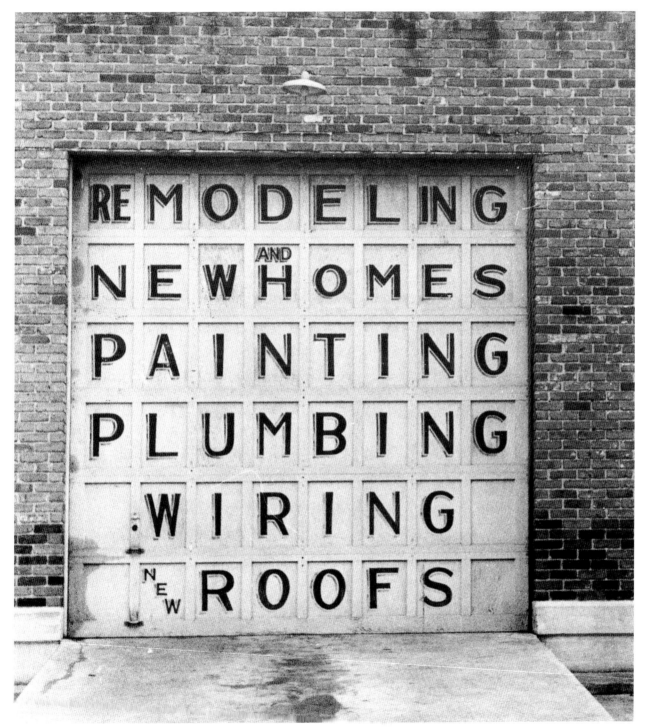

This engaging sign uses panels from a garage door. Even though it was painted by a professional, who filled in the spaces so thoughtfully, the end result has the appearance of an amateur's effort.

The presence of fresh cement on a sidewalk is an invitation for merriment. Walk the streets of a city and you'll be overwhelmed with examples. But here a store uses the sidewalk to advertise its product, and achieves a Charlie Parker improvisation. I wonder if the owner of the store had recently returned from Hollywood and a visit to Grauman's Chinese theater.

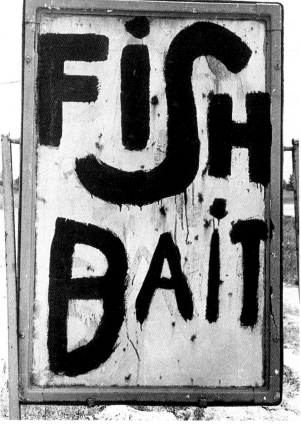

Fish bait signs are as prevalent on roads in the South as lightning bugs on a summer evening. No doubt the painter knew perfectly well that the "S" was a worm.

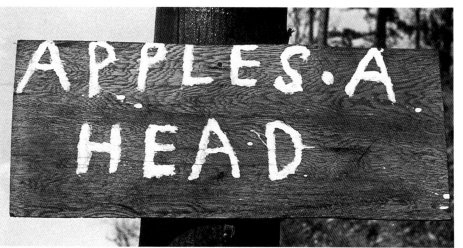

I have long tried to figure out this sign. After all, there was plenty of room for the completion of the word "Ahead" below "Apples." The sign comes from Route 41 in north Georgia, where fruit and vegetable stands abound all year round, or used to before the interstate highway moved in.

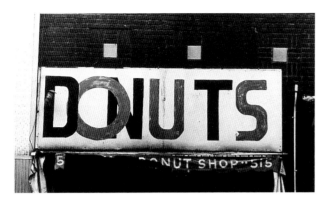

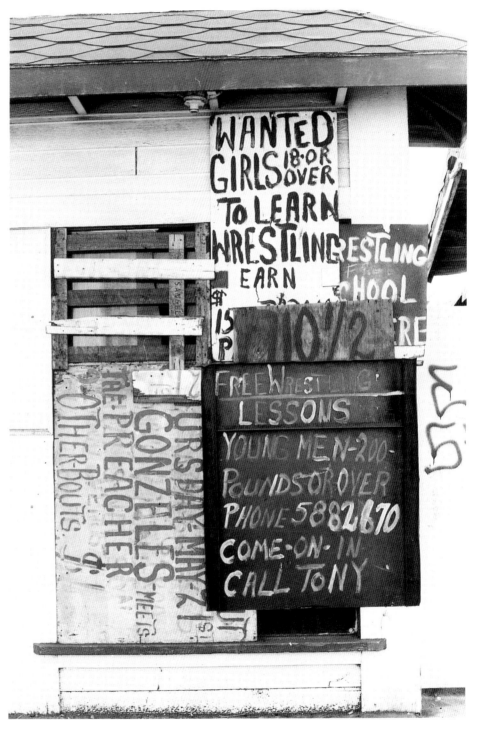

▲ This is a very sophisticated sign. The writer knew exactly what to do and planned it carefully. See how the "O" sneaks up on the "N." The painter could also have used the old standby rounded dough or doughnut type of letter, but that would have been sophomoric.

▶ Squint your eye. Do you see an abstract painting? This is a determined person who recycles signs.

I am fulfilled by signs that are filled full: full of words, names, thoughts, numbers, information, and general doses of cacophony. Letterforms of all sizes and shapes that fit into spaces of sizes and shapes thrill me. The results are often hard to read, but are always amusing and often comical. This sign is an example. Ann was in Cleveland, Ohio, in the late 1960s. That's all I know about her, except what I read in the window. I am not too bothered that most of the surface was painted by a trained sign artist. I am taken with the interruption of "New French Weaving" with "Lengthen the Hair...On Bald Scalps."

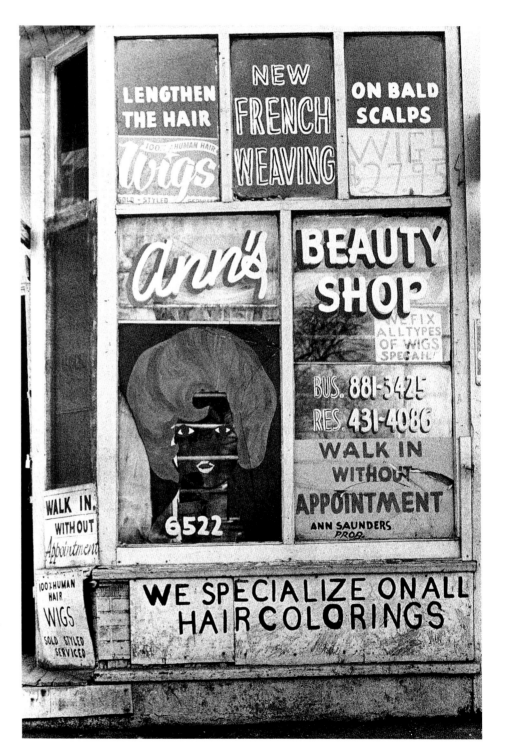

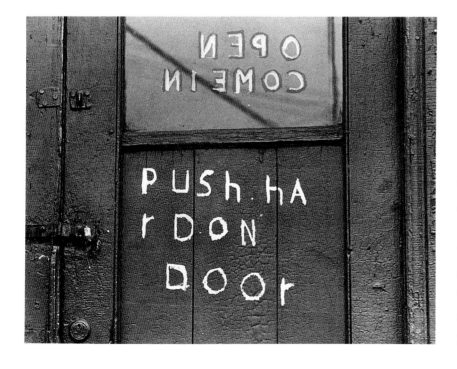

This sign was recognized by an antique dealer and was installed in a booth at a chic and pricey show in Nashville. I had to have it for my collection. It measures 22 by 42 inches and is double-sided. "Grandmother," or whoever, packed the space with as much information as possible. I adore the teensy ice cream and coffee cups with accompanying spoons. It is such a tender, sweet touch. It makes me think that "Grandmother" wrote the sign. The strong repeats of "Home" seem to confirm my theory.

"Open Come In" is not painted on the other side of the glass, it is simply painted in reverse—inexplicably. My conclusion is that it was done to attract attention. The writer was getting nervous with the next message and wasn't too sure about the space ahead. Reading the three words feels like reading an alien language—PUSh ha rDON DOOr.

An unconscious sense of design combined with rich letterforms (the lowercase "h" and "g" add color) give this operation an identity all its own.

This sign from Philadelphia, Pennsylvania, is sweet and spirited. All the necessary information is put into the small space with ease. The large "ETC" fills space well and with authority. Then, suddenly, the writer remembered the important profit center, the video game area. Thus, the afterthought was sneaked in and applied in vertical fashion.

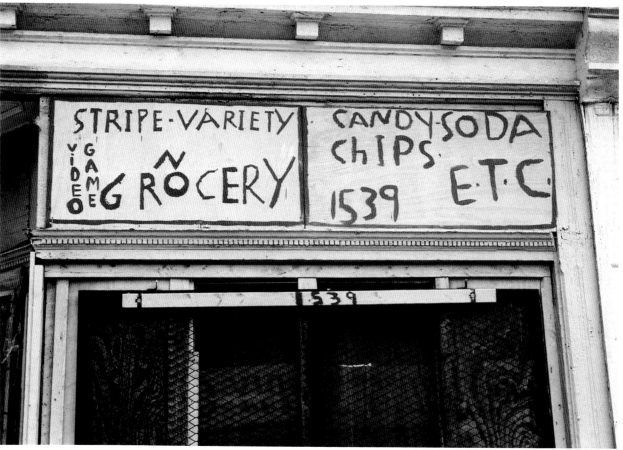

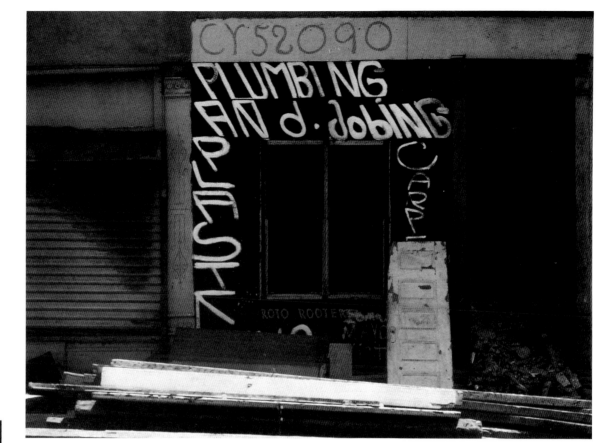

A retired trash can was used as a surface for a pleasantly illustrated ad for a store in Atlanta. The opposite side was also used as a device for illustration and lettering.

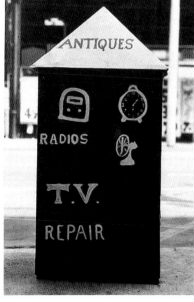

This enterprising person was proud of establishing a business. I can't tell if the writer was left-handed, left-brained, or out in left field. Were they so plastered that they couldn't continue spelling the word? Maybe they started with "E," noticed that space was running out and turned it into an arrow. I particularly like the serifs on the "G's" and the lower case "o," "d," and "b."

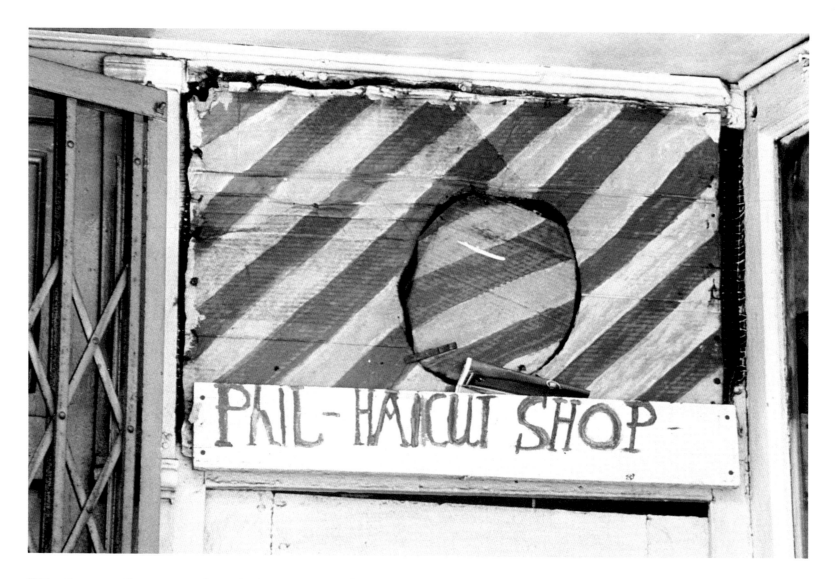

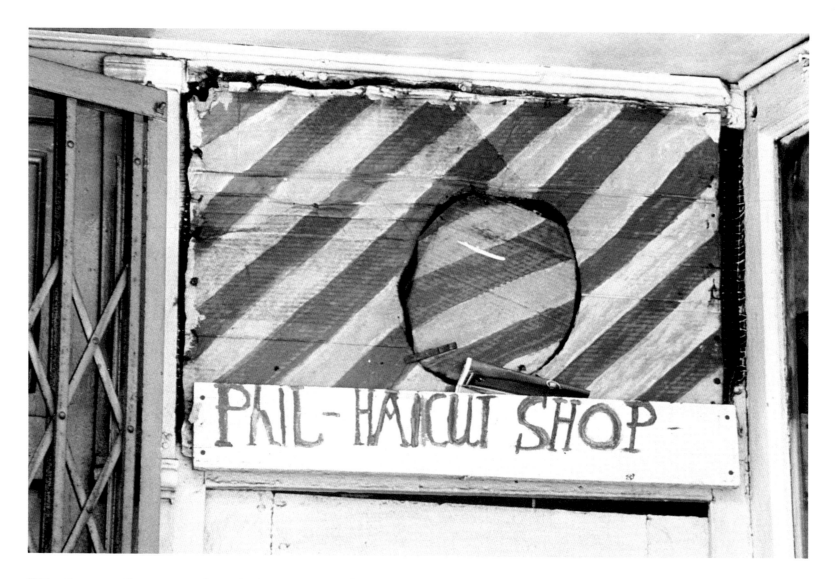 Conceptually this sign reminded me more of a minimalist painting than a misspelled sign. (Remember when stripe paintings were a hot art world ticket?)

The cut-out circular form, which replaces and doesn't match the intended stripe, sure beats any stripe painting I've ever seen.

What's behind that darned circle?

Most people who have sign consciousness first notice misspellings. Such signs draw attention to themselves, awakening senses. Misspellings, however, are heartfelt and poignant, though they are often amusing. They may result from an uneducated hand, an unconscious slip, or through haste.

I care for the uneducated hand. I care that those people need to communicate. Their voices come from the depths of their hearts, which gives them a sense of purity that can transform their messages into poetry.

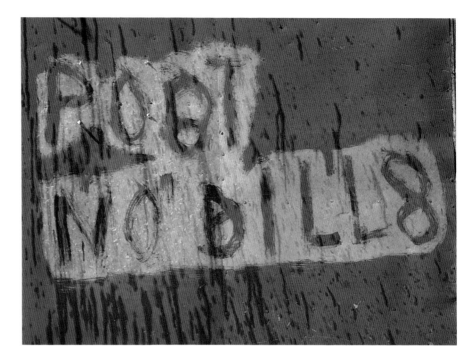

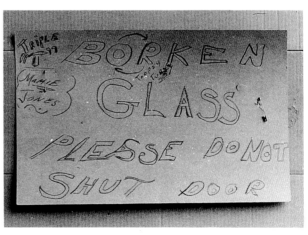

I believe this writer had a hidden aspiration to become an abstract painter. Look at the "S" forms; they're trying to be "8"s; the "B" in Bill began as a "D." What was this artist imbibing?

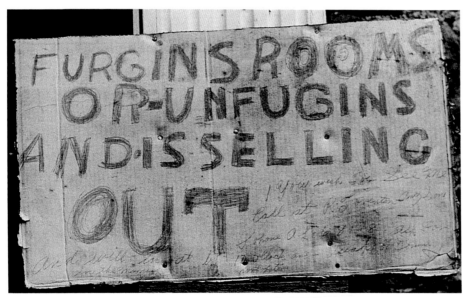

A pair of dysfunctional spellers.

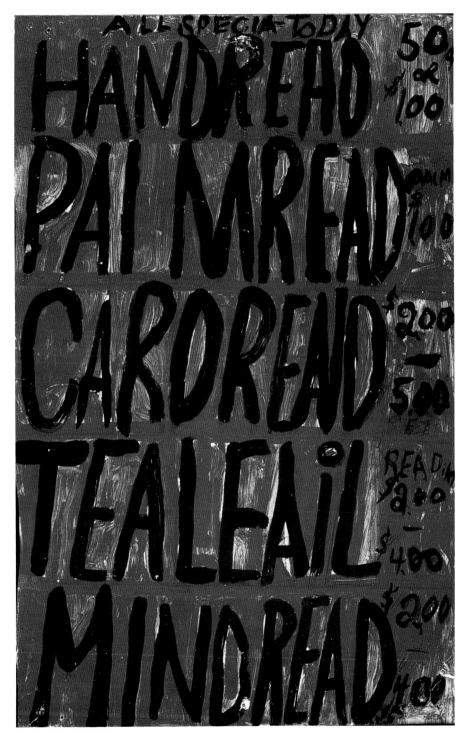

A favorite sign that I own is this two-sided jewel. One side, painted in a dark, dusty pink household enamel, shows a great deal of frustration. It seems apparent that the "handreader" was the writer/painter. Whoever it was took a breather in going to the other side of the paper; or did they get a palm reading indicating that they should switch hands with a paint brush? A large mystery is the word "TEALEAiL." What is it, tea leaves?

I am more attracted to this inspired "O" than to the misspelling. The writer seems to have an unusual fixation on circular forms; note the circle dots on the three "I"s.

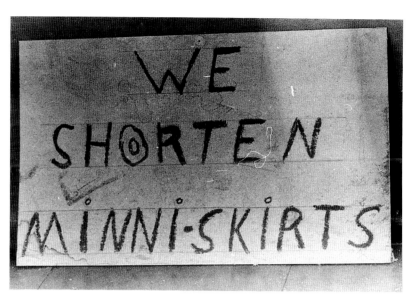

As the price of the product suggests, this sign was found in the early 1960s, in Alabama. A linguist devoted to southern speech will notice the southernness in the misspelling. The spoken emphasis is on the last syllable, which explains the double "T." Depending on the region there could be several pronunciations. This is the quick, back country version.

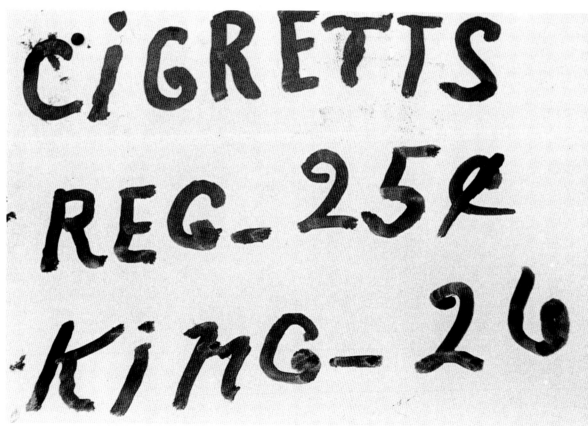

This sign from my collection is dear to me for its simplicity. It's not the misspelling that intrigues me, nor the lack of awareness of space. It's that after studying it for a while I realized that the magic was in the fact that the writer seems to have taken a giant strawberry itself and used it as a tool. The juice has a watercolor painting look about it.

Approaching a north Georgia fruit stand that fronts a farm house, I became tickled with this sign. Perhaps the writer had a form of dyslexia when spelling the word "sale."

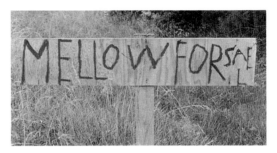

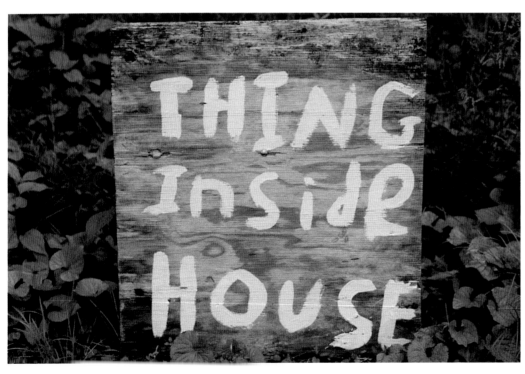

This sign was acquired for me by friends who have sign language consciousness. It was discovered at a junk emporium, where stuff was to be found in front, behind, and beside a shack, and, as the sign indicates, inside as well. Why the proprietor neglected the plural, we do not know. Perhaps it was a recollection of the 1950s sci-fi film *The Thing*.

69

▼ Gang graffiti on a wall in New York City. Almost prehistoric, it was done in the late 1960s before gang graffiti would proliferate over in the five boroughs of New York, and beyond. Here, one of the Dragons realized the misspelling, took a few giant steps to the right, and made the correction. Notice the subtle, but heightened drama in the name Dragons, and the possessive apostrophe, as if to say, "This is our turf."

In 1993 I returned to the same wall. It was completely covered by other gangs and their visual violence. Very faintly visible was the Dragon's signature.

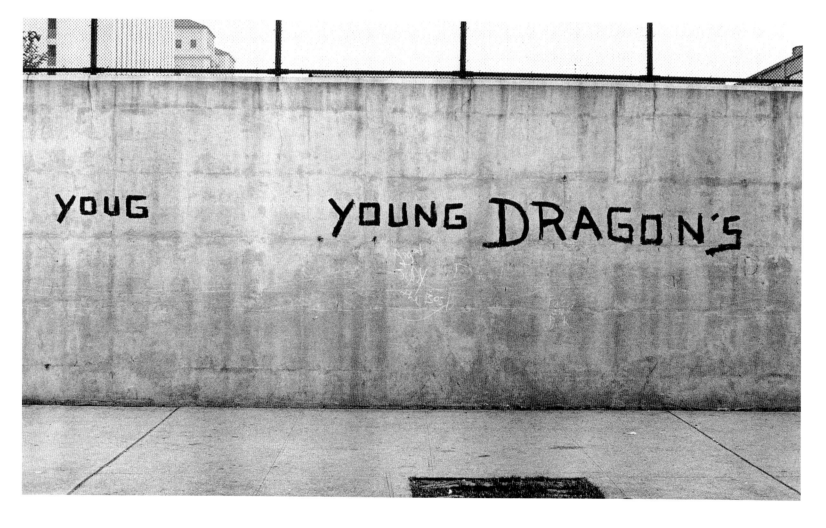

I found this sign down the block from where I lived in New York City. It was next door to a parking lot where my car resided. It reminded me of a "No Smoking" sign I once saw that I always interpreted as NOSMO KING.

Old POSNOBILLS probably knew how to spell, but was in a hurry to get on to endeavors of more importance.

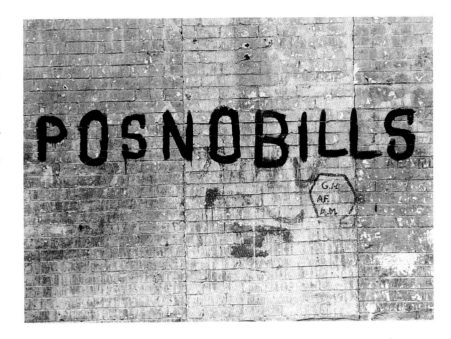

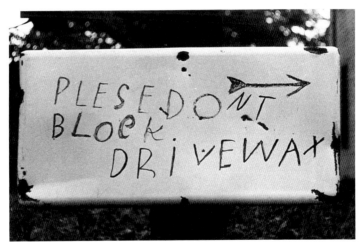

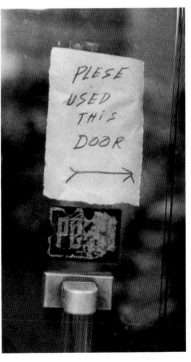

Remember when you were very young and your parents were teaching you manners and to say "Please?" Remember that you didn't know how to spell it? This way seems to be softer.

I cherish this sign. It was the first in my collection, a gift from my dear friend, Ken Kneitel. The letters are hand carved in wood and attached to a metal panel. The misspelling was surely noticed by the sign maker. Did laziness set in to prevent the correction?

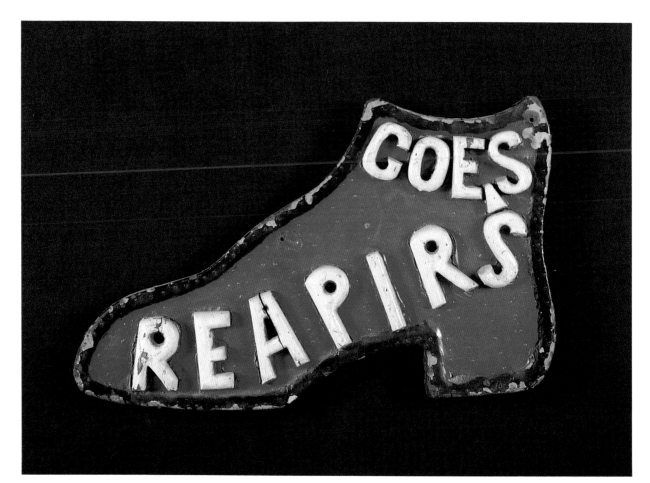

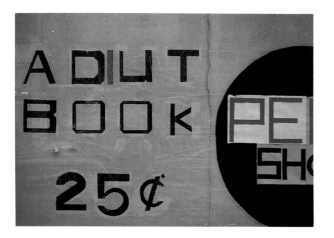

Here's a lovely example of taping, and some subtle clean-up brush work with yellow paint. The writer realized a mistake and aimed to remedy it with red tape, but there was no room for a capital "L," so a lower-case version sufficed. The sign was found in lower Manhattan.

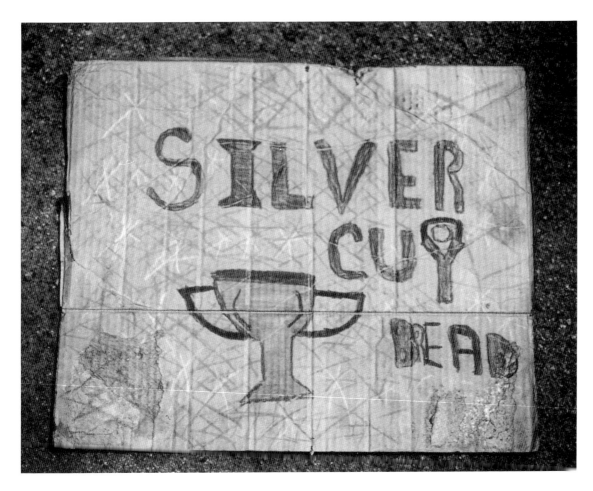 Another sign from my personal collection that brings joy. The covered "Y' shape after "CU" stands for "P" for those who are not familiar with Silver Cup Bread. The writer wanted to turn the "P" into a cup. (Was this before or after the painting of the red cup?) Notice that a corrective impulse was at work, an "R" tries to elbow its way in beside the "B" and the "E."

BEAUTY IN LETTERFORMS

Anonymous unprofessional sign writers often create letterforms spontaneously. With no typebooks or trade magazines to follow, they sometimes construct highly original letterforms using a variety of materials. From a simple script to elaborate block letters laboriously drawn, they make their way through the alphabet. The charm of these writers is their lack of pretense; the style comes straight from their hearts.

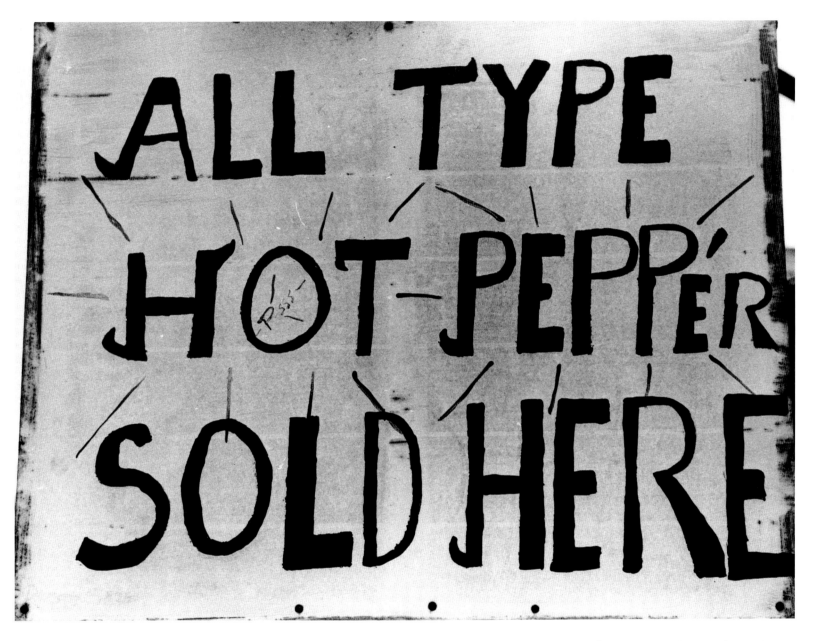

I found this sign in New Orleans, no surprise. It was painted appropriately red, too. Examine the nimble "hot flashes." But why are they so feeble?

My favorite expressions here are the little turnups on some letters, clearly a visual notation of "hot." Are they horns from Mr. Devil, who lives in a hot place? And what about the little, sizzling "Psss" inside the "O"?

The prices date this New York City garage sign as around 1967. The sign works on a couple of levels. Squint your eyes and it turns into an Egyptian tablet. Squint again and it could be a Mark Tobey painting. In normal focus it reveals a consistent, forthright, ambitious sign maker who really cared.

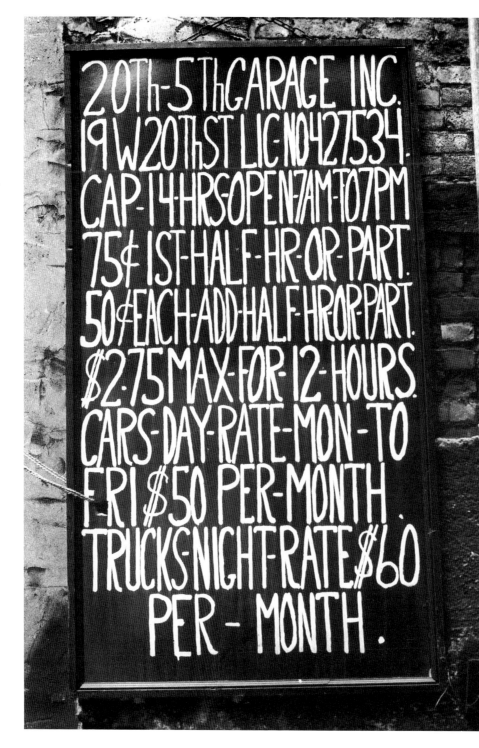

This sign begins sheepishly with a script "G," followed by a more aggressive "A" and concludes with an "S" that's not quite sure of itself. But the dainty "2" and the strong "9," accompanied by the angled "9/10" have a certain harmony, aided by the four circular forms. The sign is unified with three strong horizontal bars serving as guides that echo the clapboard.

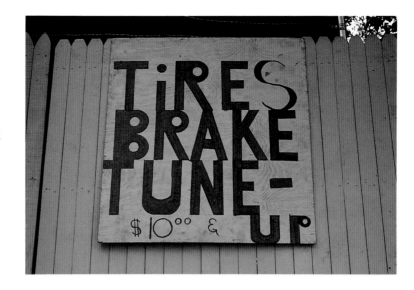

A wall in the north end of St. Louis brought multiple chuckles. The letterforms hugging each other and the spirit of the hands are funny. Even the washed-out ghost of earlier messages below add whimsy and color to the initial impact of this wall.

A square-ended brush adds boldness and stength to these letters and the sign painter handled the circular forms of "R," "B," and "P" fearlessly. Panic set in with the "S."

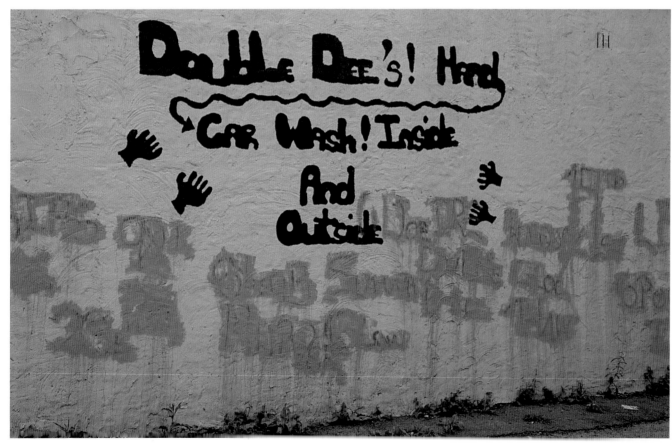

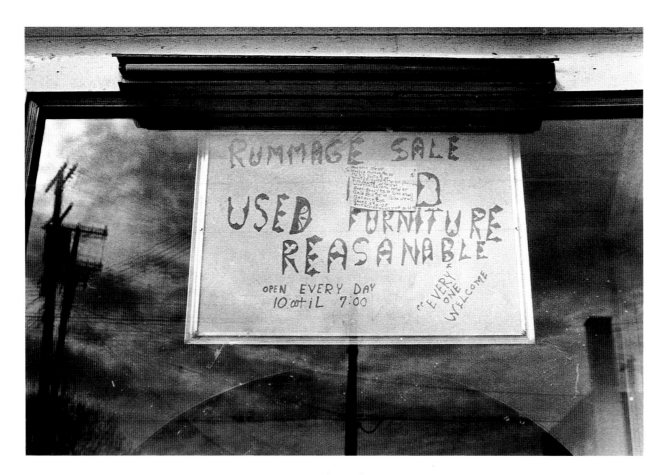

The architectural frills of the French Quarter in New Orleans had their effect on this sign.

A simple arrow shape for direction combines with a fine example of a closed letterform. See how the "O" is not filled in, but is done with a delightful swoosh of the brush.

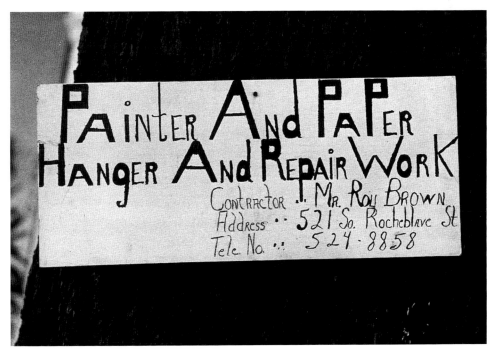

I get the biggest kick from people who have a compelling need to dot their "i's." This is very common with anonymous sign writers. Does it come from early days in school? Putting in periods is another matter.

Here's a case where panic set in after the first word. Then, a sudden stroke of confidence took hold and the artist mixed and matched boldly. Notice how the circular forms take on another energy.

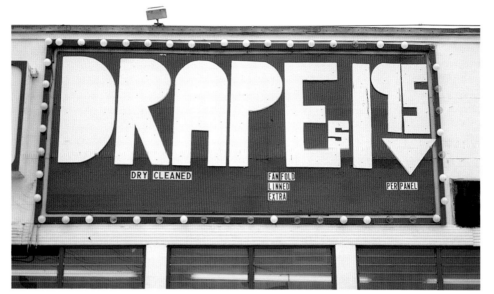

This beautiful sign was lovingly cut out of plywood. The filled-in letters are strong and dramatic, but was the sign maker simply too lazy to cut out the open spaces in the letters? The addition of store-bought stick-on letters adds a nice counterpoint to the handmade headline.

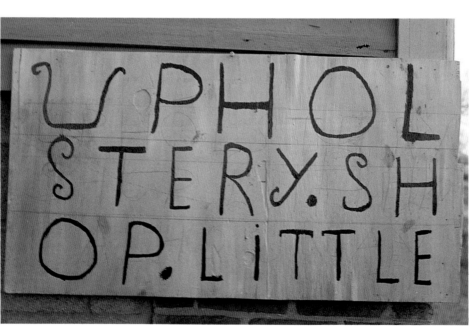

Who says that words have to be complete on one line? The regular spacing and consistent letterforms, along with the curls of the "U" and "S," add authority and finesse to this elegant sign. "Little," presumably the owner of the shop, may also have found joy in the little dot over the "i" and the two emphatic periods.

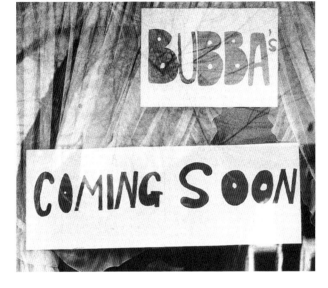

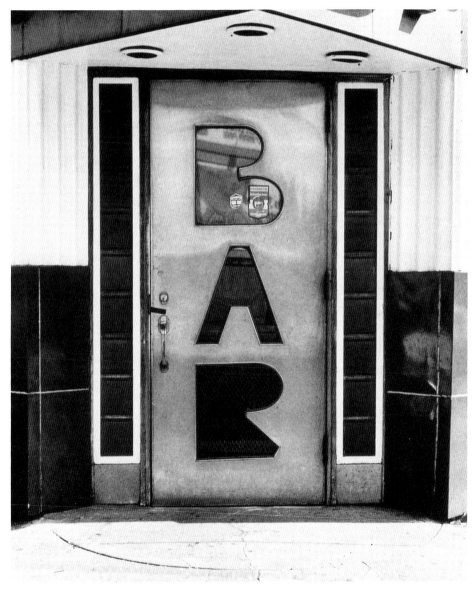

Here is another example of how the filling in of oval and circular forms gives emphasis and importance to a sign.

Oddly enough, this sign is from New York City, and not somewhere in the south.

Hoboken, New Jersey, was the home of this home-made door, with letters hand cut and surrounded by leatherette. Door as sign. Brilliant.

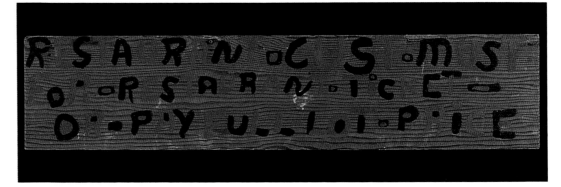

There is always a story connected with my sign acquisitions. This sign—compelling, artful, and amusing—was lifted from a parking lot in lower Manhattan. Red and black paint must have been on sale when this was made. And legibility was not a premium. The writer may have been in a hurry, or wished to be vague. After close scrutiny, however, you'll get the message: even if you're a restaurant customer, if you don't get your ticket stamped you'll pay full price for parking. Notice the filled-in circular forms and use of both red and black in some letters. Nice jazz.

Brook took his business seriously. He hired a semi-professional sign painter with imagination. The elaboration of the illustrations is powerful and space is used optimally.

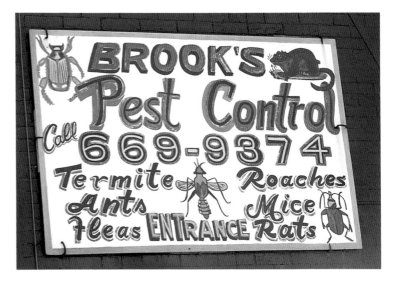

▼ This supreme Bar-B-Que sign was just down the street from "Stripe Variety" (see page 62). Look at the ghosted name of the previous owner, Famous Mr. C and what looks like a cow. I'd like to have sampled Mr. C's victuals. What happened to Mr. C?

Here, the letterforms make me happy. Filling in closed areas in letters is a spirited exercise that continually amazes me. The instinct to do it is universal; closed areas are inviting. Have you caught yourself doodling, filling letter loops? There is much satisfaction staying inside letterform boundaries.

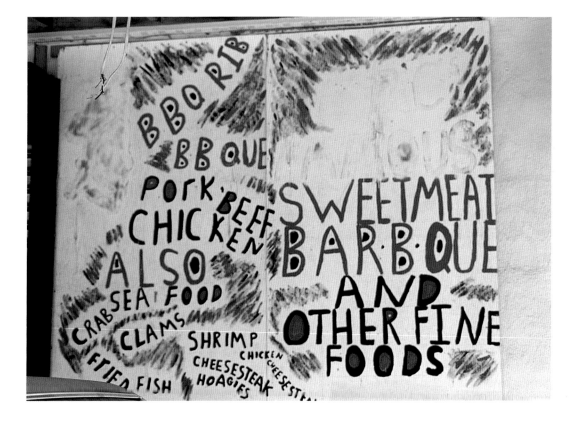

83

▼ Stimulated by the name of the shop, the sign writer let imagination run wild. The combination of the "UE" is a typo-delight: the flourish of the "U" contrasts with the formal and thickened "E," a sophisticated example of what can be done with linear contrast. There was some talent going on here.

▶ Another square-ended brush handled more confidently created this handsome fish.

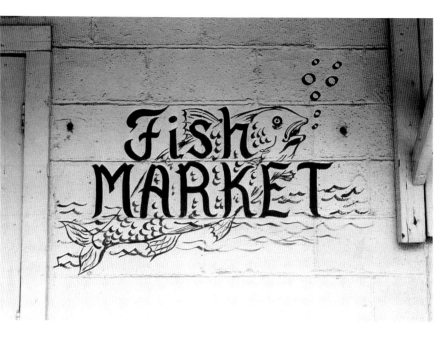

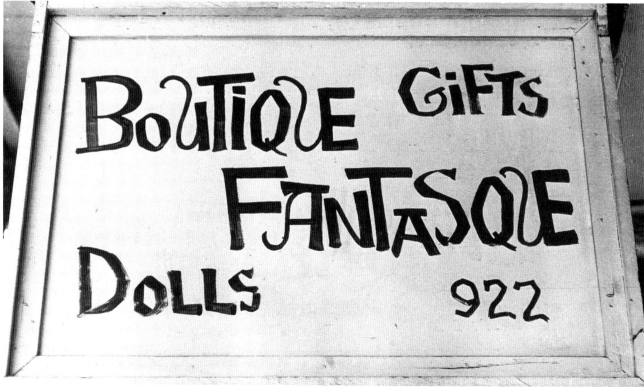

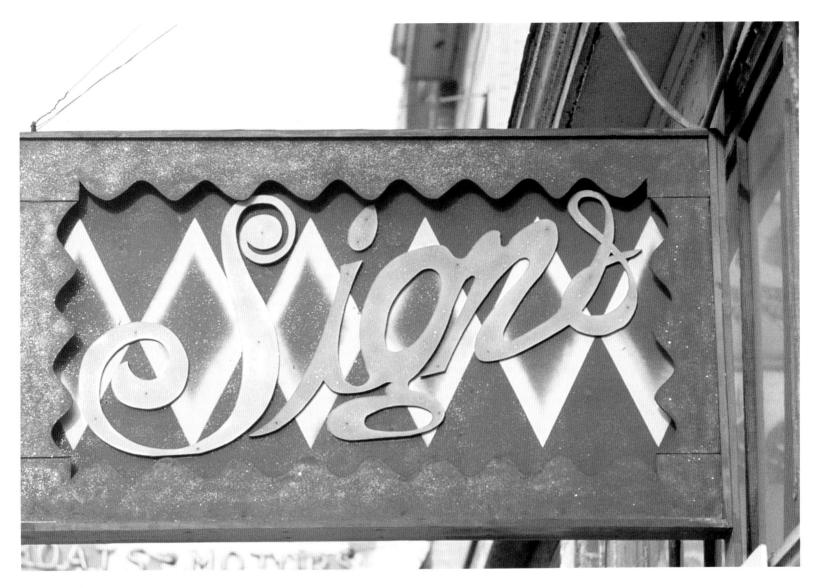

This sign shop owner was too clever for his own good. He's produced an unreadable sign. The handcrafted, cutout script letters were the first mistake. Charming as they may appear individually, they don't read. To compound this, the background of shaded diamonds destroys the curvaceous letters. Was the artist confused by the scalloped frame? I think so.

All of us have been involved with graffiti at one time or another. Think back to the blackboards in grammar school. Writing during class doesn't count, but after school were you ever compelled to use a blackboard as a target for your emotions? You had free range to explore—especially in classrooms other than yours. You wrote something, then ran out of the room down the hall and out the door. That's graffiti.

A tree with initials, or directions, carved in it is probably the earliest form of graffiti. In more modern times chalk was a handy tool for writing on sidewalks or building walls, and we all knew it would wear off, didn't we? Spray cans and marking pens are not so innocent.

Messages of all kinds are expressed on many surfaces in our world, from restroom walls to the buttresses of highway bridges. Sex, religion, and politics are the number one topics; love found or lost, college and fraternity signatures, and doses of personal venom.

Some have romanticized graffiti as the natural expressions of personal passions. It is true that some graffiti is harmless and innocent, an ebullience of good spirits. And although some graffiti does not greatly harm the surfaces it is written on, it is all inherently destructive. No doubt social ills prompt these expressions, but the lawlessness and desecration of public and private property cannot be tolerated.

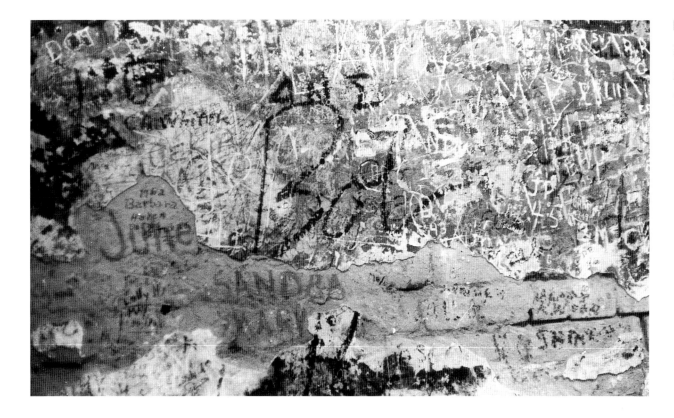

A concrete wall in the French Quarter in New Orleans circa 1964.

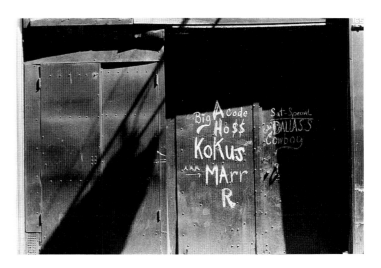

Cryptic wall markings on a metal doorway could be hobo writing, a language unto itself.

Close-up of a large storefront that was soon to be demolished in Stamford, Connecticut, circa 1970.

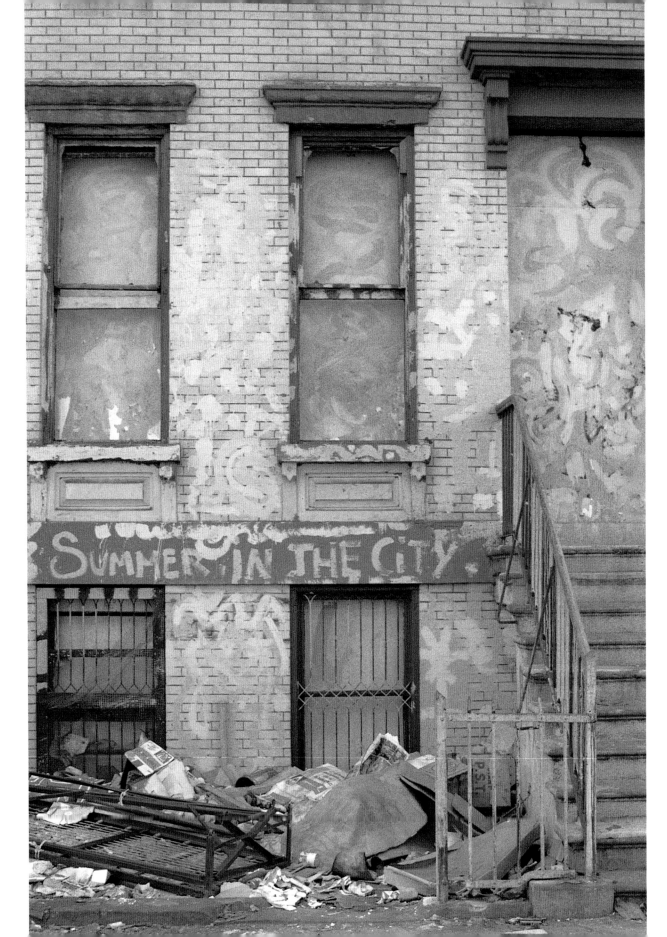

A closed-up brownstone tenement on the upper West Side of Manhattan.

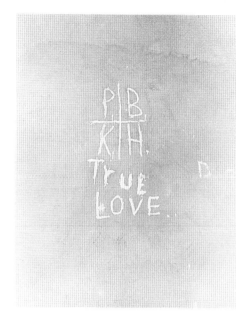

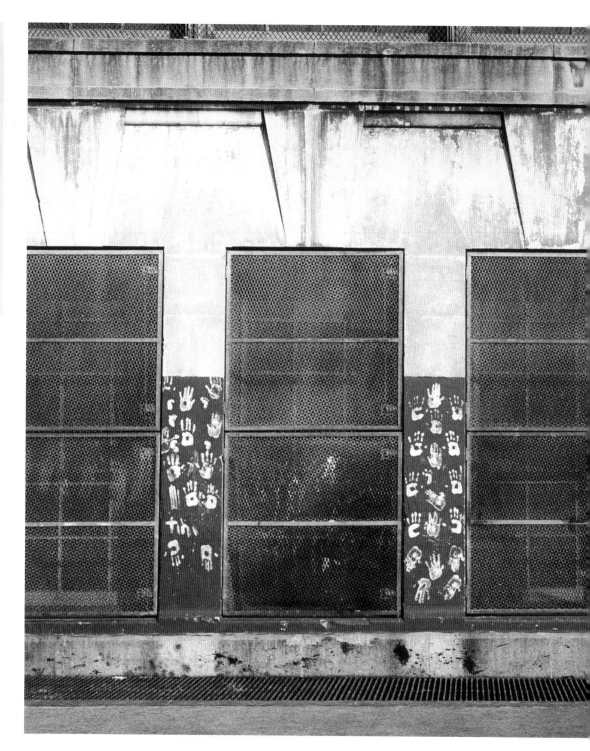

The quintessential initials of love on a painted concrete wall, an echo from the carved tree trunk of old.

I don't find this wall hostile in appearance. The hands are a lovely sign of life and a well-used metaphor for marking a place as one's own. Hands have appeared on walls since prehistoric times in caves and in rock shelters throughout the world.

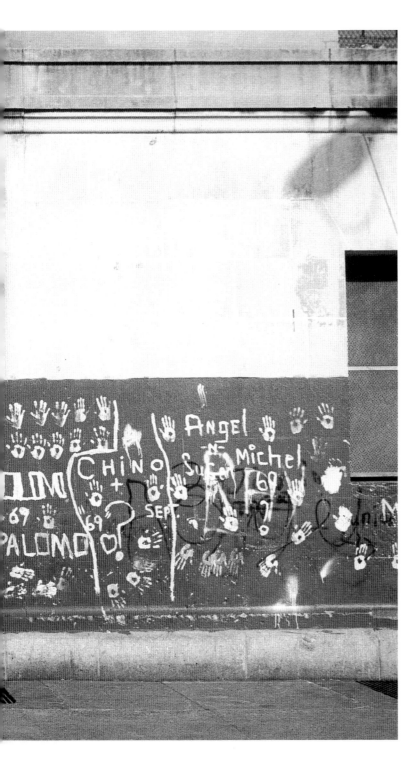

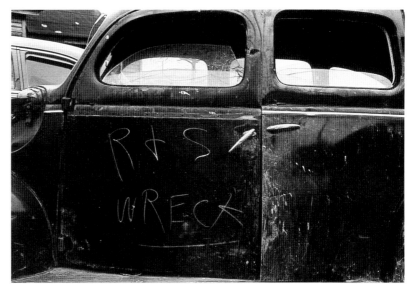

A wrecked automobile forms a slate for writing.

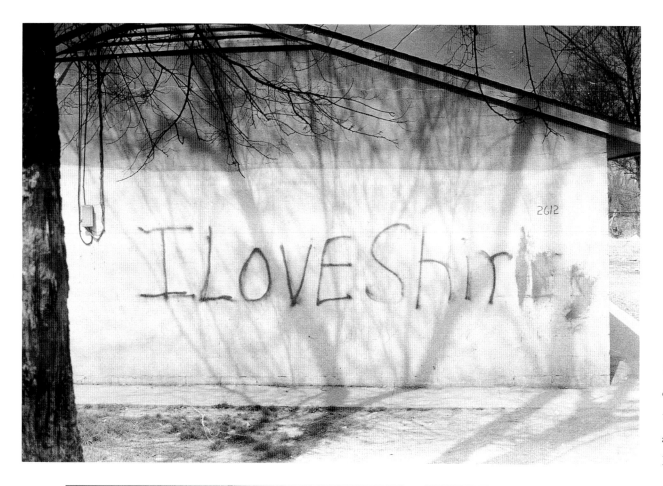

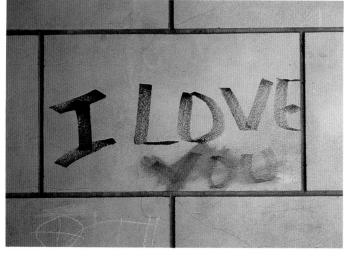 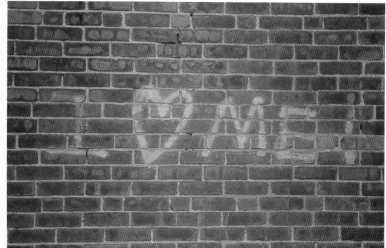 Three expressions of love; two have had erasure attempted on them. Had love died?

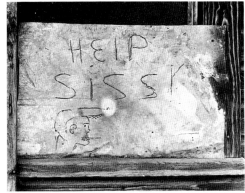

A cry for help, crayon on metal.

Some spirited finger work from young hands and hearts marks a window in Atlanta.

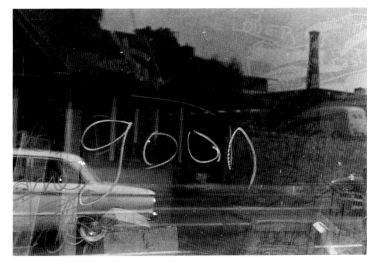

A word in soap, possibly a Halloween leftover.

The most common "no" sign is "No Parking." All of us have experienced them, probably on more occasions than we like to remember. How many times have you parked at a "No Parking" sign? Parked to see if you could get away with it? Parked because you didn't believe it? Parked because you were frustrated at not finding an unprohibited parking space. Or for a myriad other reasons. The "No Parking" sign that has been altered is my favorite. Adding to or taking away from the declaration can turn a benign sign into one of power, purpose, and oftentimes, gaiety and humor.

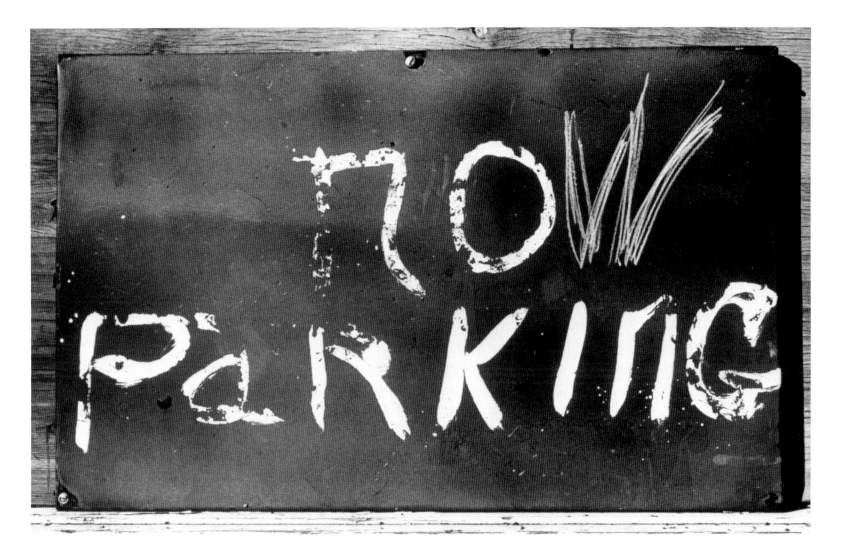

Next to "For Sale," the most common sign in the land is "No Parking."

Here, a benign graffiti artist has changed a warning to an invitation.

Seldom does one see a "No Parking" sign with no "No." Notice the delight in the apostrophe and quotation marks.

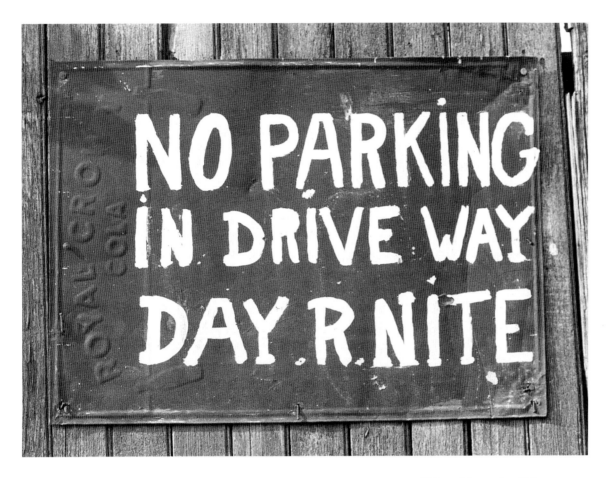

Here we have an inventive variant of the old, familiar "Chat 'N Chew" or "Beans 'N Rice" formula.

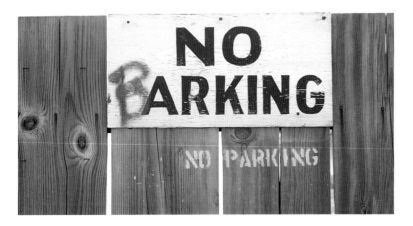

Where the "P" went we don't know, but clearly the impromptu spray can artist was no dog fancier.

▷ ▽ ▷▷ These are classic examples of poor planning.

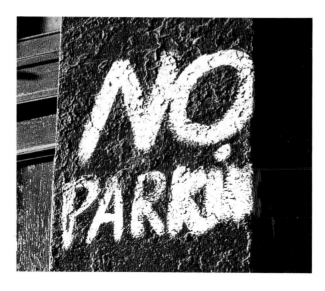

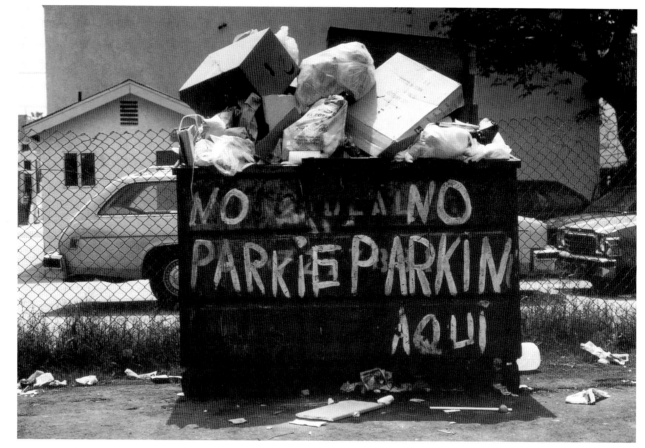

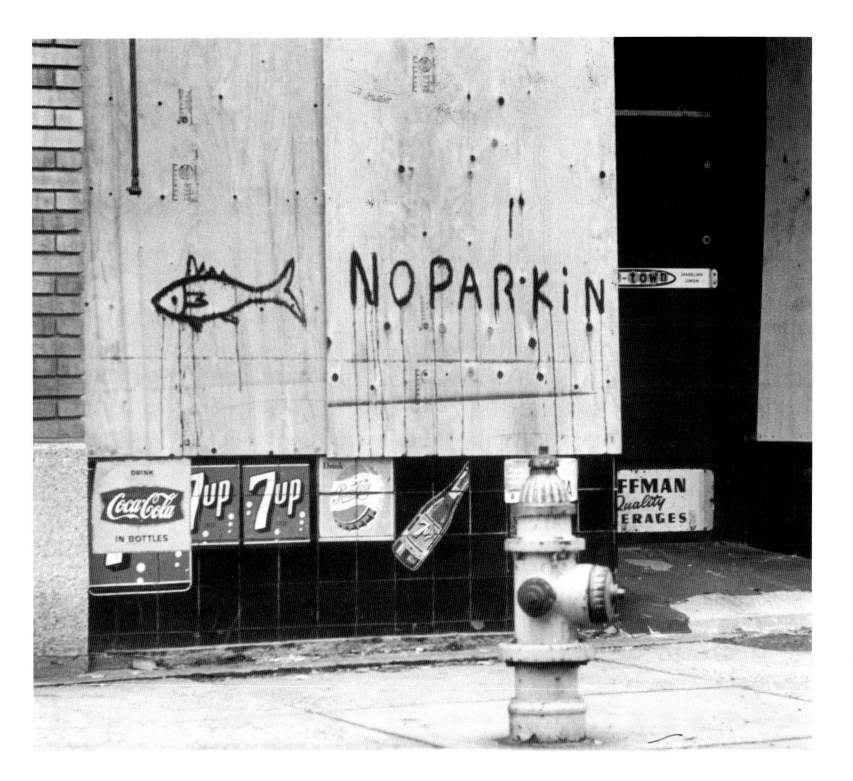

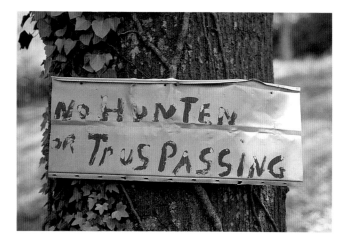

These are some other things you may not do here.

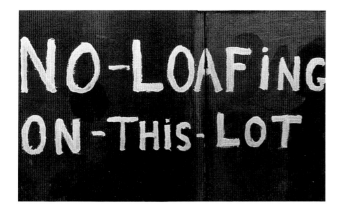

I notice a proliferation of "No Loitering" signs. No doubt this is a drug culture demand. "No Loafing" is a more "down home" variant.

Having said what they wanted to say with room still left, this sign writer added a heartfelt reminder.

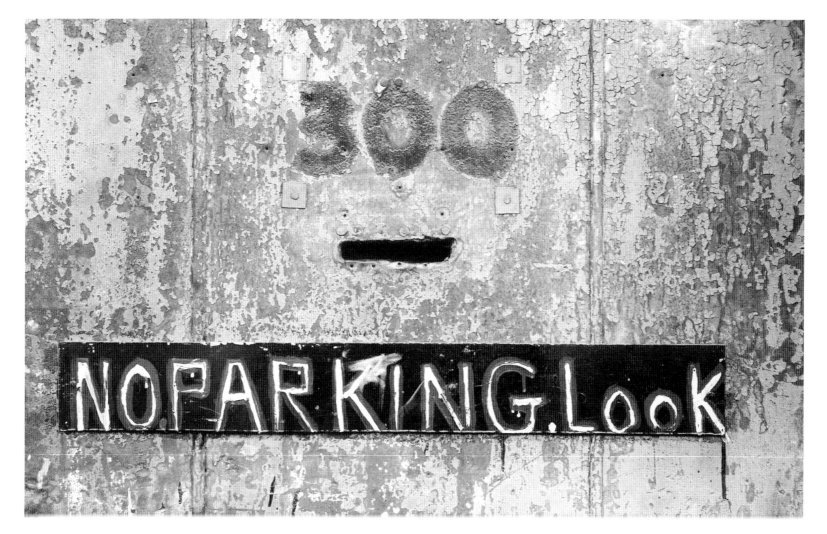

Among the beach houses at Marina del Rey, California, there is a serious owner who favors English spelling and unveiled threats.

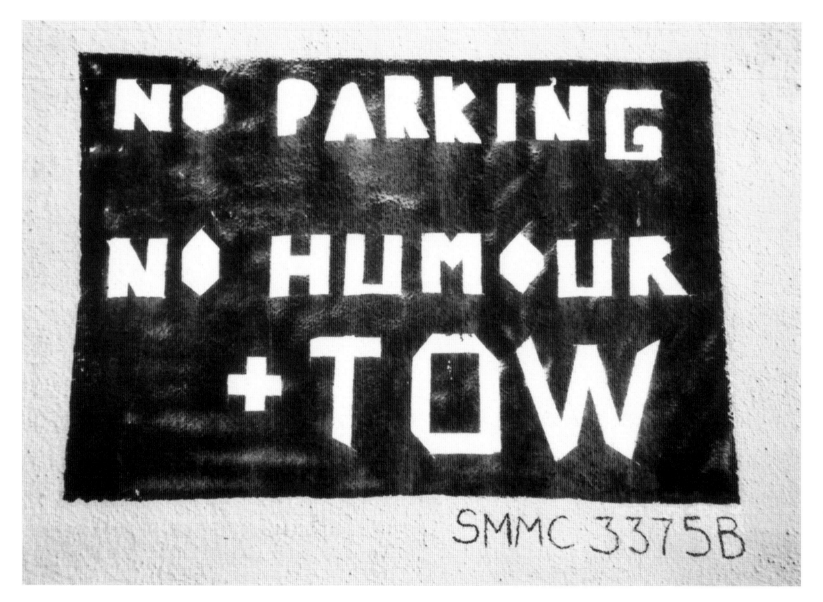

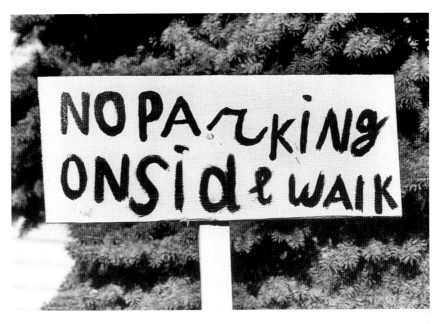

A recycled gas station sign has been transformed into a hard-to-read but charming exhortation. I particularly like the seriousness of intent and the way in which the scrolls take on more importance than the message itself.

Of course not, there's not enough room.

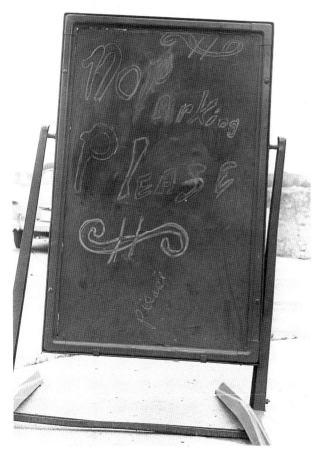

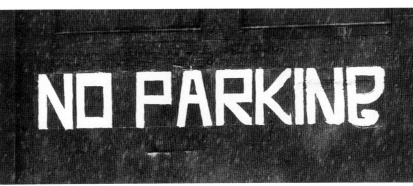

How often do we see the best intentions of mice and men come to nothing. This writer started off so well, then tired, lost concentration, and couldn't get to the finish line without stumbling.

Availability of a surface on which to paint is an essential of sign language. Cardboard, a discarded piece of wood, the side of a box, a crate slat, a simple piece of paper, or other scraps are familiar mediums for the sign producer. But perhaps most familiar of all are the walls of buildings. As shown in these early postcards, buildings have long served as mediums for signage.

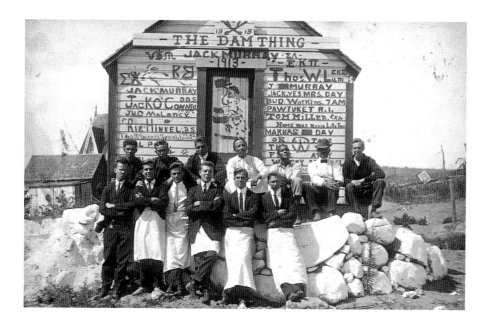

"The Dam Thing" must surely have been a haven for many jolly meetings of the mind and spirit—and spirits, too. But the inscriptions on the front wall are not advertisements; this seems to be a kind of clubhouse of young men, who appear to be working as waiters or hotel kitchen staff, and some of whom belong to fraternities. A quaint meet-

ing place, marked by a skull and crossbones, dated, and "signed" by many. A story of some interest no doubt lies behind the door.

As for Mr. R. A. Stow, he needed a surface as big as a building front to announce his varied business ventures. I figure ol' Stow added activities as time went by, beginning in horse and buggy days and continuing into the new era of the automobile. Why he didn't employ the naked side of the building, a likely site to show off other enterpreneurial skills, is a mystery, except that the corrugated metal siding would have been no fun to paint on.

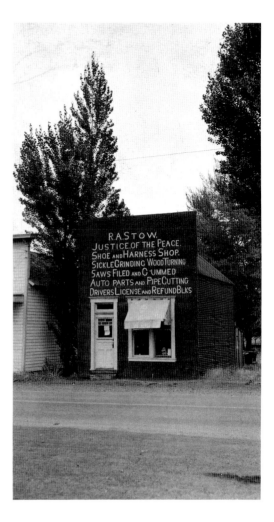

In downtown Manhattan we can only speculate on the riches that await us within.

Someone with a great deal of imagination saw the whole storefront expansion and instead of making the sign smaller conceived of using the window as the letter "O." Brilliant.

The chevron stripes on the door posts and window frame should have been enough to identify Otis's shop, but he was taking no chances.

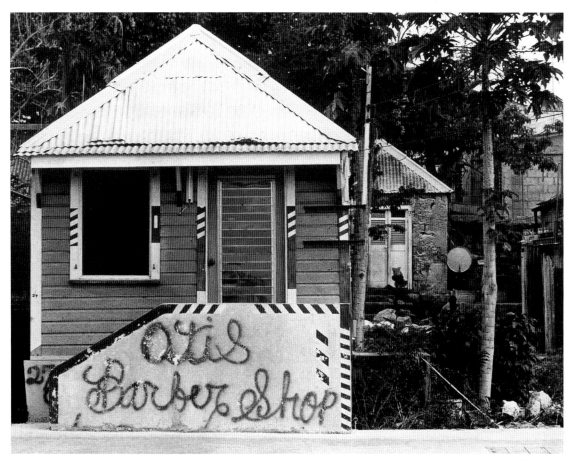

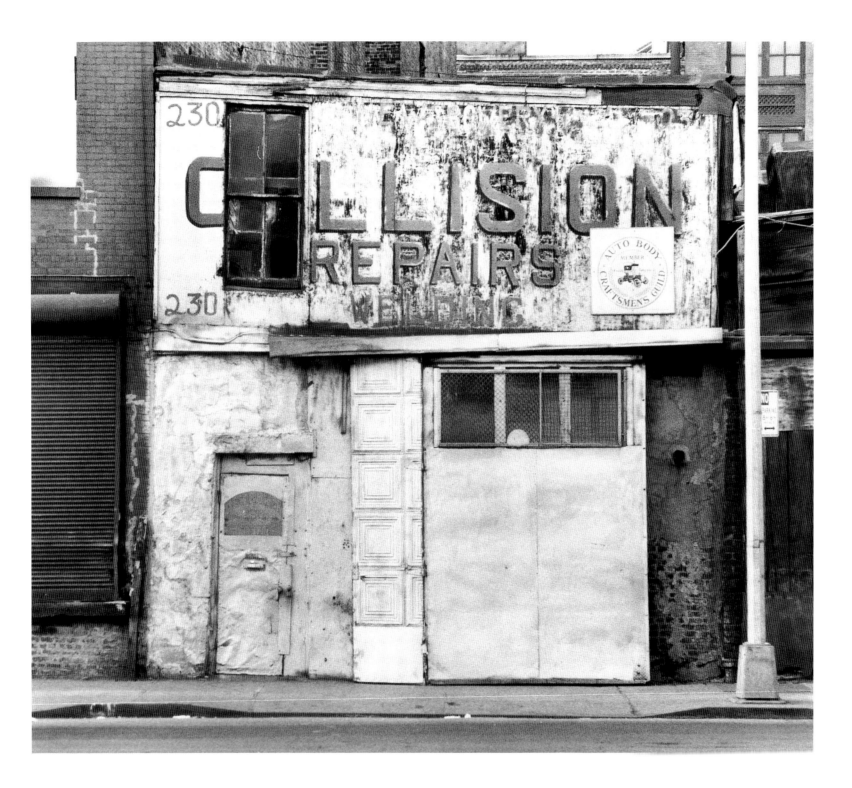

It may rain in on The Music Lounge in Savannah, Georgia, but you are guaranteed to have some kind of fun inside.

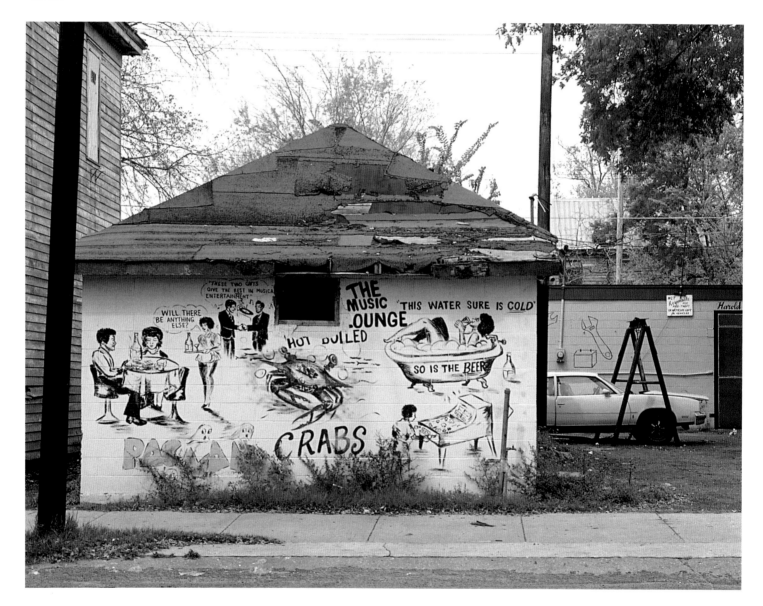

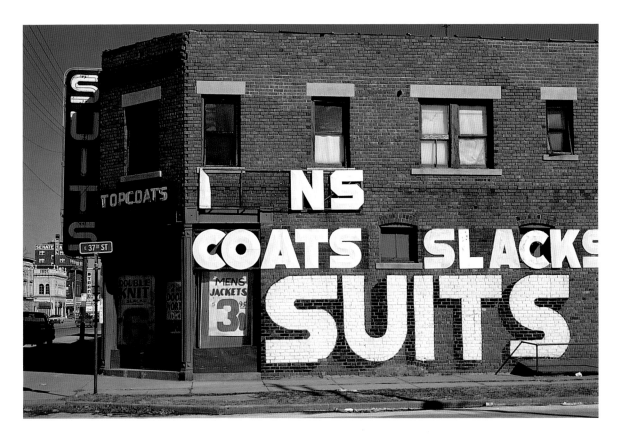

These tympani symphonies assert themselves with shouts, not whispers. Why fool around with window signs when you can use big spaces?

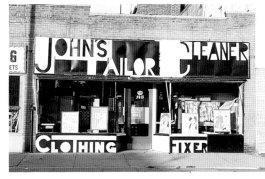

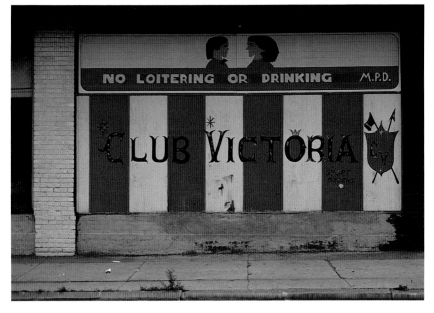

Club Victoria invokes the power of the Memphis Police Department to maintain orderly premises.

Storefront churches are prominent in black neighborhoods throughout the country. Their signs serve as invitations to newcomers and reminders to the faithful. Some signs are executed with authority, dignity, and conviction. Some are done in haste. All are sincere. Many are poignant. None need commentary.

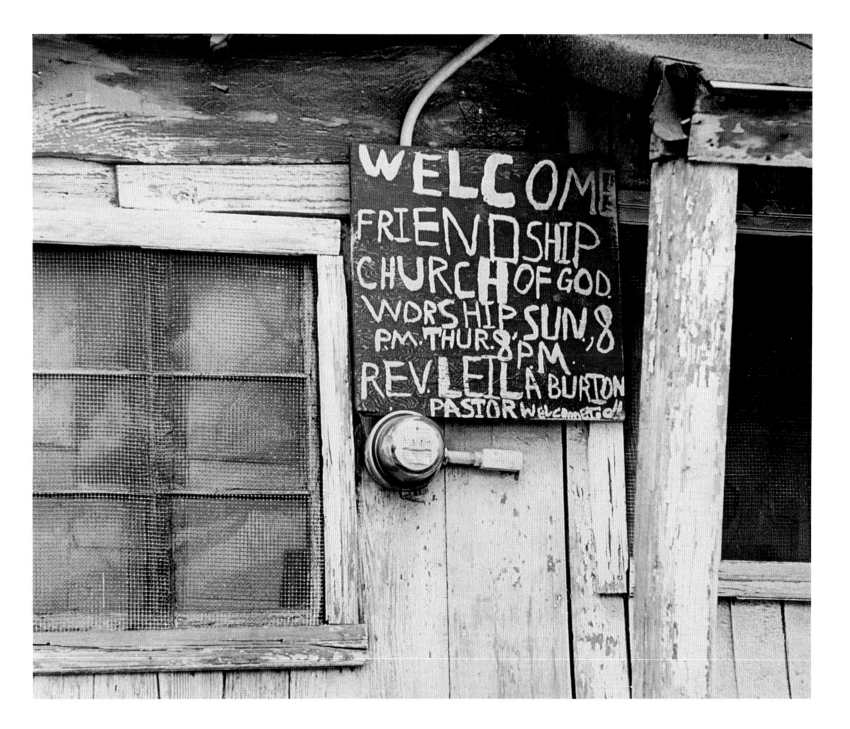

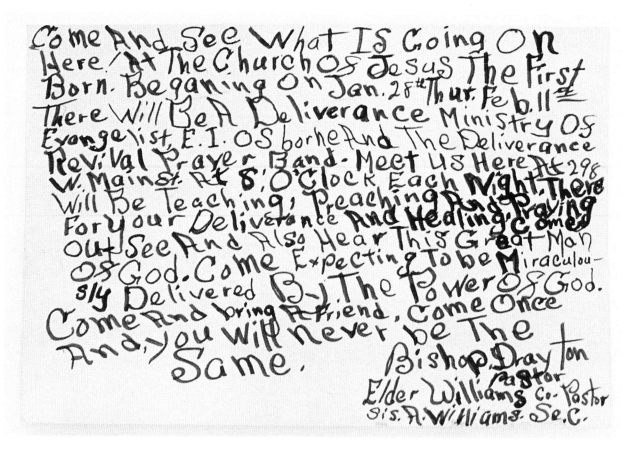

Come And See What IS Going On Here! At The Church OS Jesus The First Born. Beganing On Jan. 28th Thur. Feb.11th There Will Be A Deliverance Ministry Of Evangelist E.I. Osborne And The Deliverance Revival Prayer Band. Meet Us Here At 298 W. Main St. At 8' O'Clock Each Night. There Will Be Teaching, Preaching And Praying For Your Deliverance And Hedling Come Out See And Also Hear This Great Man Of God. Come Expecting To be Miraculou-sly Delivered By The Power Of God. Come And bring A Friend, Come Once And, you Will never be The Same,

Bishop Drayton Pastor
Elder Williams Co-Pastor
Sis. A. Williams Se.C.

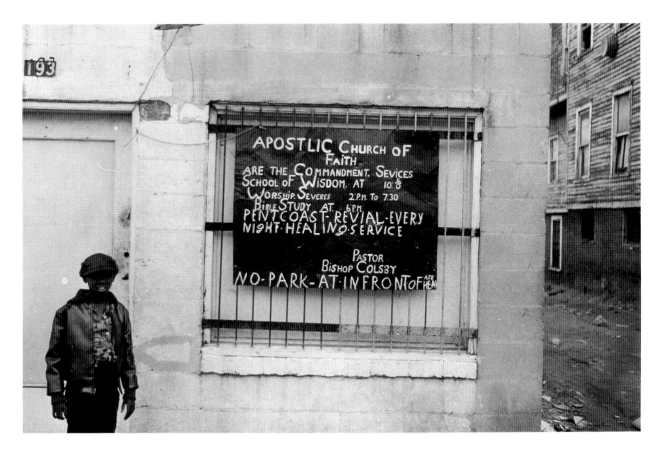

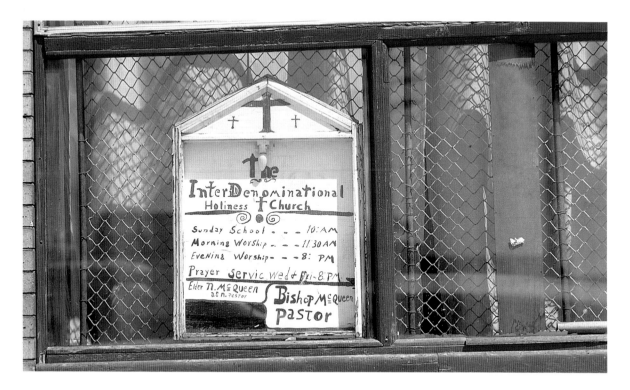

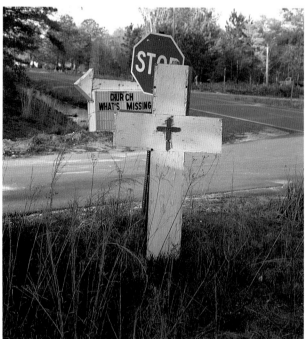

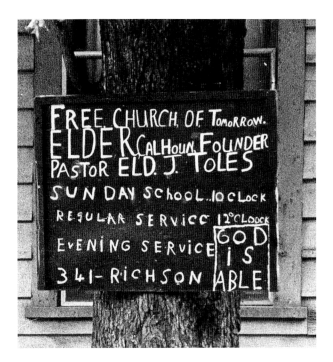

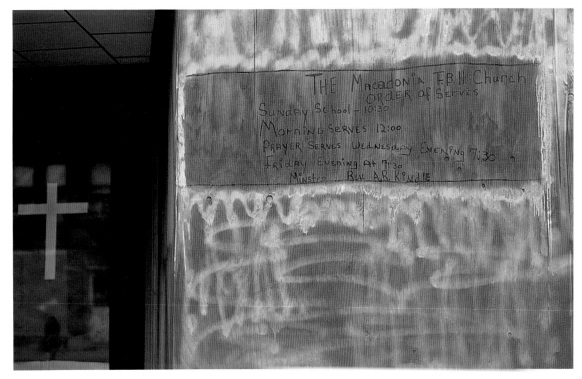

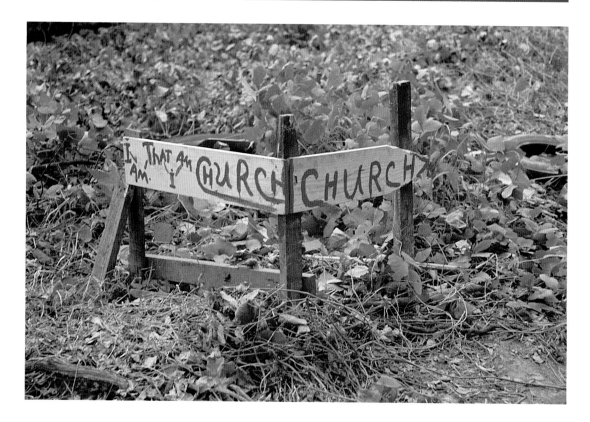

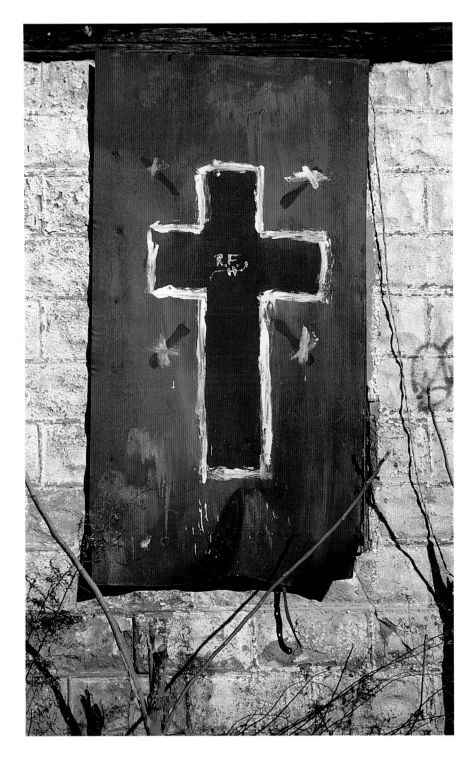

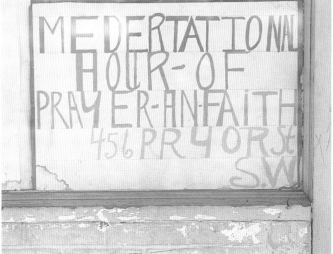

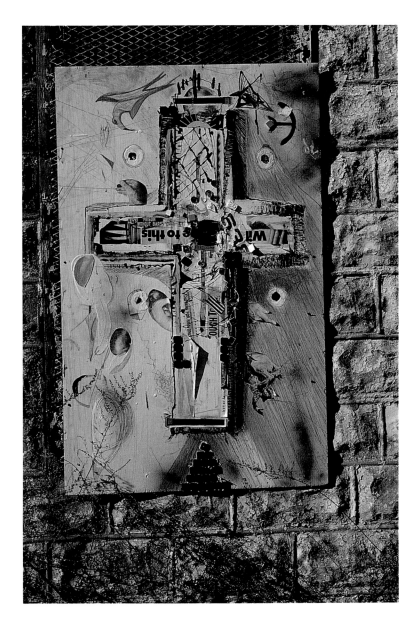

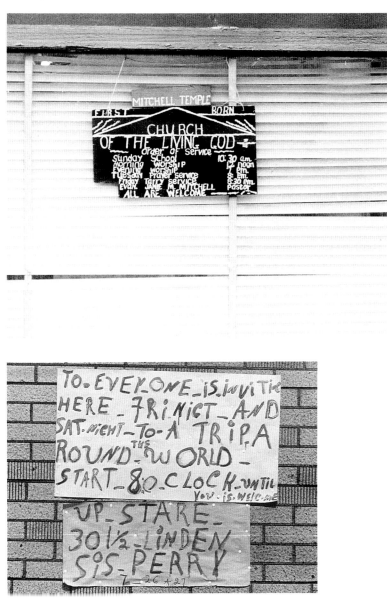

Streetside scam operations are prevalent in larger cities. Among my favorites are fortune-tellers—they are so obvious. The stereotypical dark, rotund, oily person who tells your future (by crystal balls, playing cards, tea leaves, pencil shavings, or whatever) is quintessentially one with a shady past. I believe it is in their genes. I have always wondered how they pay their rent, but apparently there are enough gullible folks who are literally lured in off the street. P. T. Barnum was right, and I know.

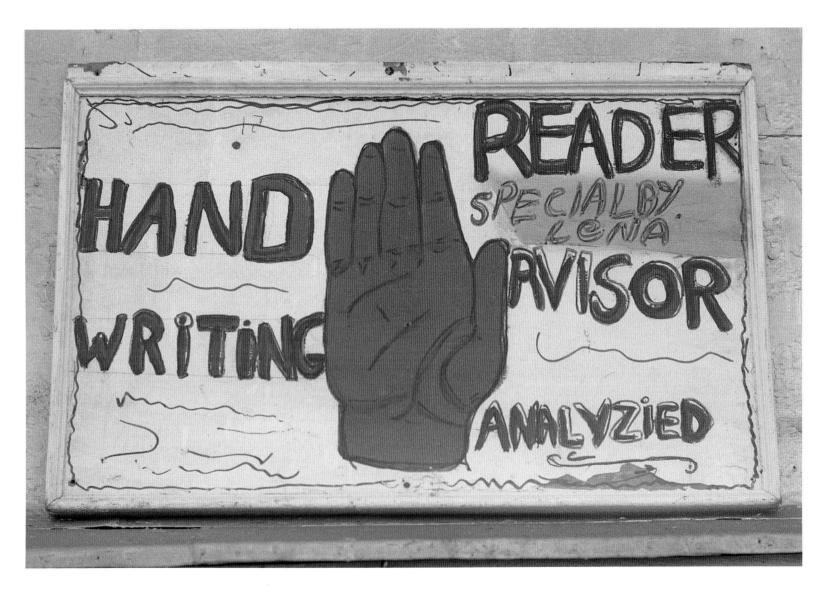

There are so many storefront psychics in the five boroughs of New York City that a book could be devoted to their decor, their personnel, their urgent invitations, and, of course, their signs.

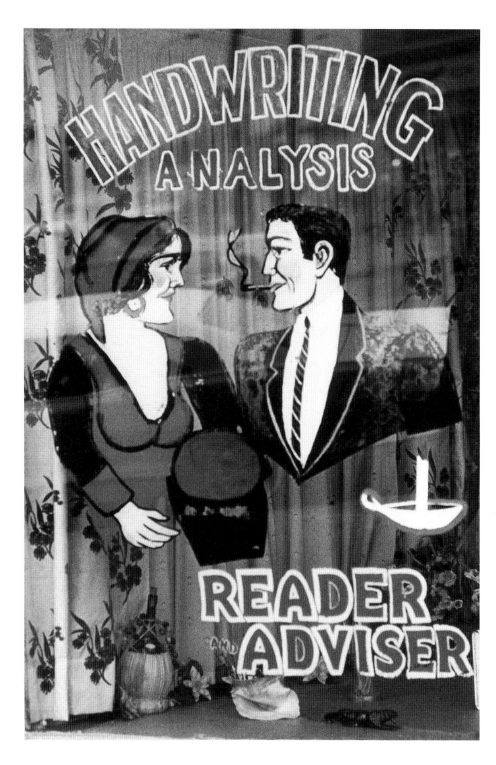

At a storefront in lower Manhattan, an analyst and her client make a fine-looking couple.

Mrs. Roberts can read, she just can't rite.

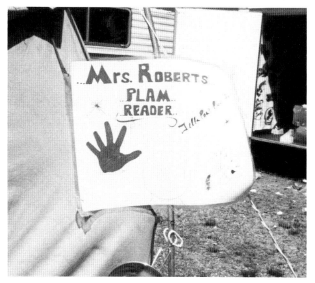

There must have been a quantity discount at the sign painter's.

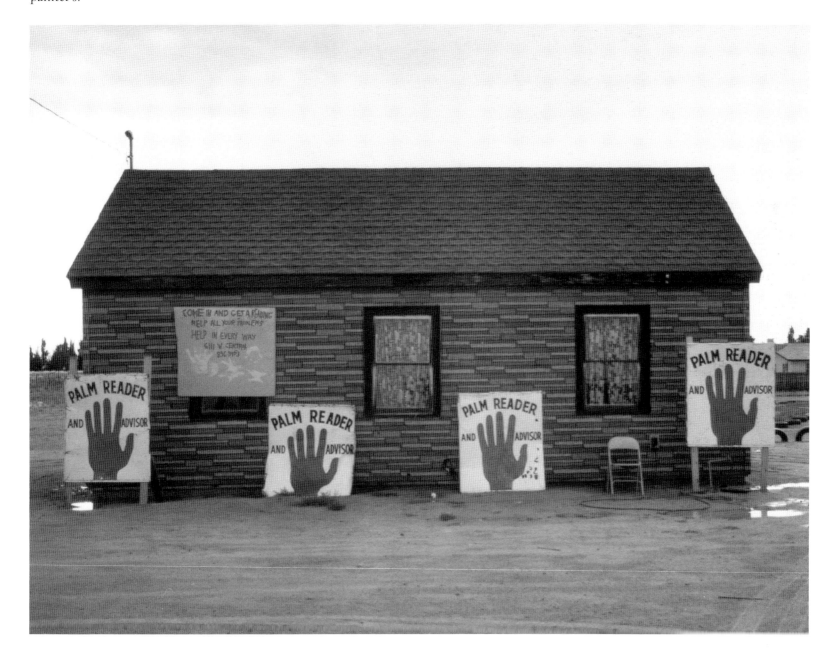

▼ In Memphis, Tennessee, Ruby used to do an Indian number, but she's gone up in the world.

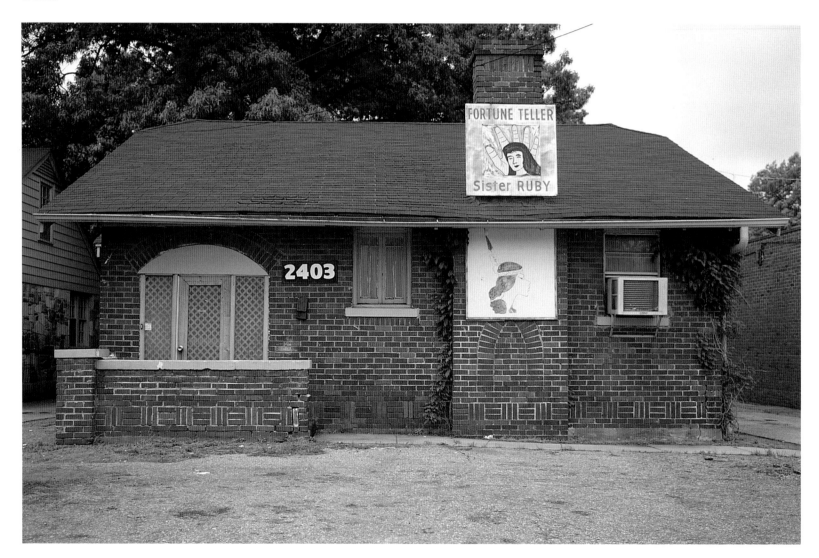

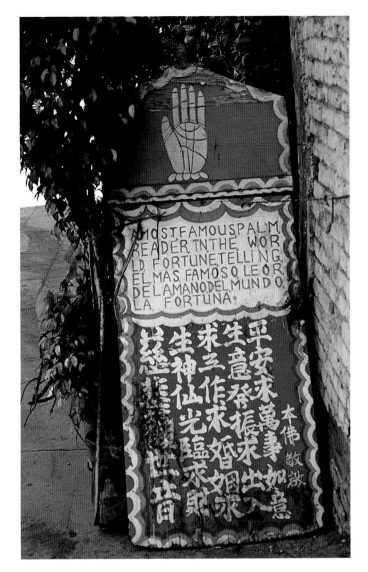

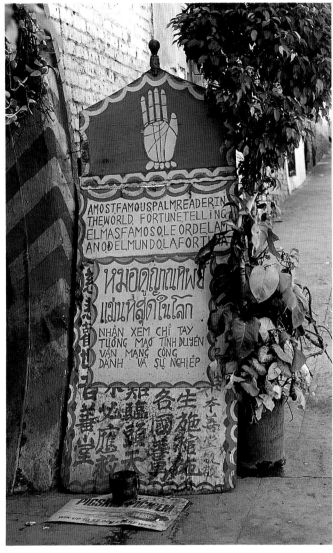

For all that New York is multi-ethnic, this Los Angeles palmist spells it out. But then, of course, this is the most famous one in el mundo.

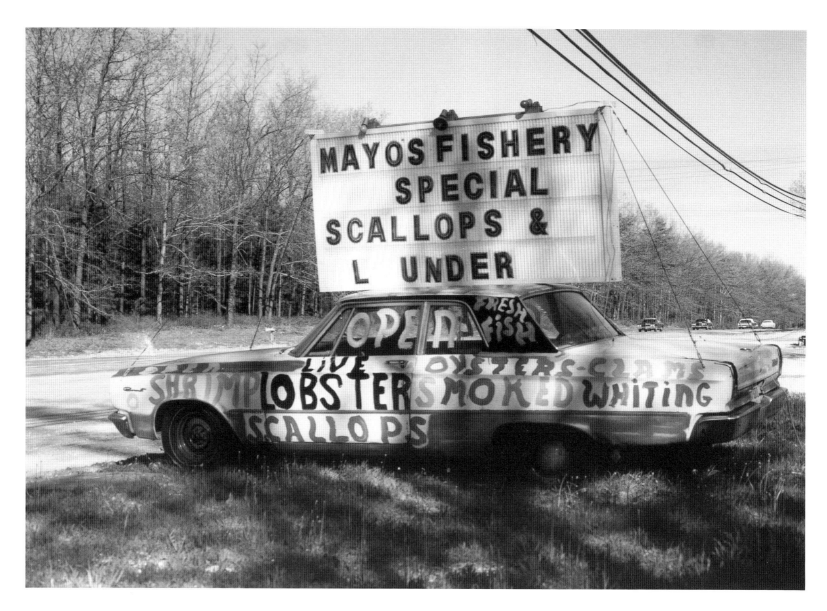

If you've got a dead car it may be worth more as a sign than at the junkyard. But Mayo's Fishery in south central New Jersey didn't trust the wildly painted car so they invested in a commercial, "arrange-the-letters-yourself" sign. Now all they need is a spare "F" and "O."

Like buildings, vehicles also provide logical surfaces for signs. And why not? Vehicles are also exposed to public view, and they have the added benefit that their mobility offers a unique opportunity to spread a message widely. Even after a vehicle has stopped for good it may be transformed into other uses. All vehicles reflect their owners in one way or another, expressing personal style, ideas, and feelings. When a person has a further need to communicate, a vehicle can become a billboard for a variety of expressions, or a medium to advertise budding and blooming enterprises. Recyclable art is in the public consciousness today. I believe that vehicles of all kinds—automobiles, trucks, or buses—are among the most fitting examples of this form of sign language.

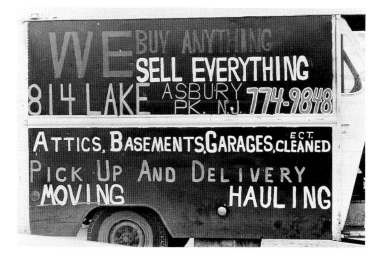

This truck mural was executed by an artist of considerable skill. And the owner of the business trusted the art enough to leave off the written word.

This unnamed junk dealer is prepared to do almost anything you could ask.

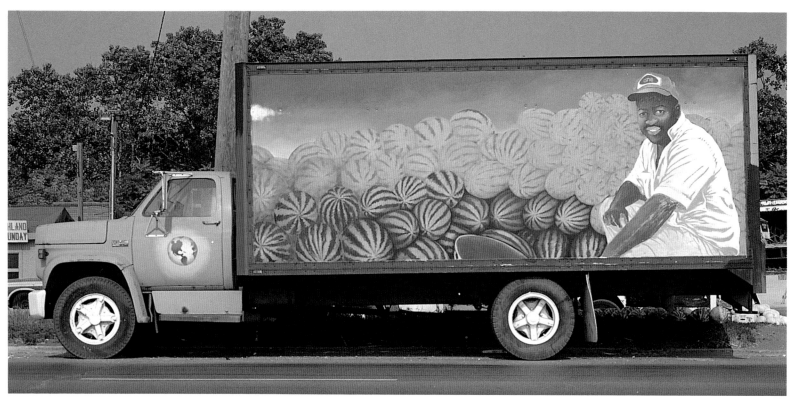

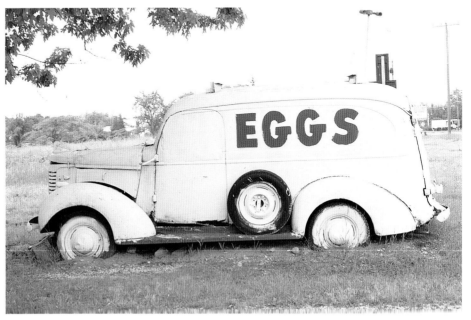

In the Pennsylvania farmland a simple coat of white paint makes the message clear: truck as egg. Magic.

I spotted this truck on a busy Los Angeles street and chased it many blocks before it pulled off the main drag and stopped, as if on my command. I asked the driver for permission to take a picture but he didn't seem to understand me. He was Mexican and spoke no English. I speak no Spanish.

Suddenly, a woman and five children piled out of the van and hid in a nearby doorway. The poor man's family evidently thought I was taking pictures in order to deport them.

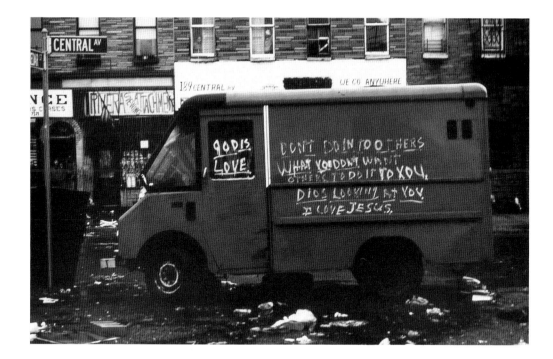

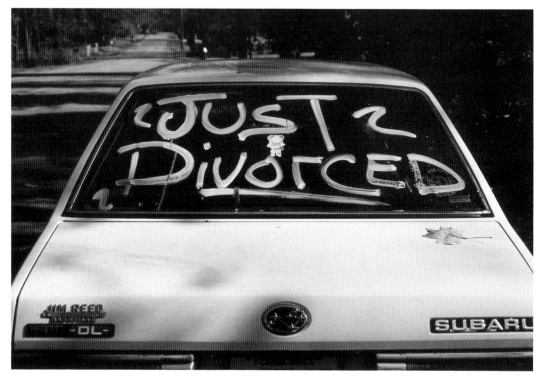

▶ Signs commemorate all manner of events.

America's romance with the automobile has led to an abundance of auto-related signage: from a junkyard Plymouth, to a war protest pick-up, to a cryptic message adorning the rear of a school bus in 1968, and, on the opposite page a van spreading the gospel in Queens, New York.

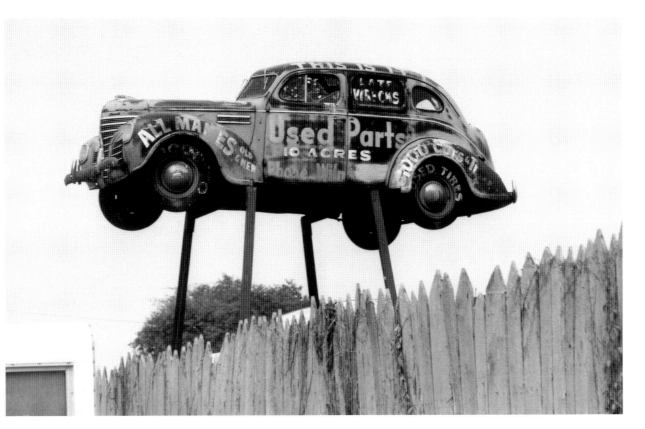

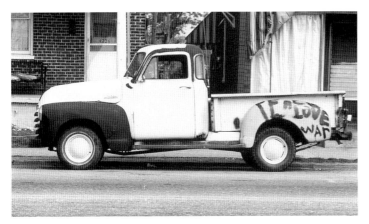

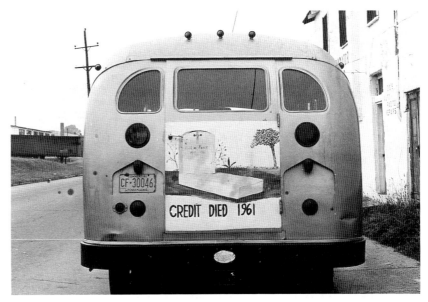

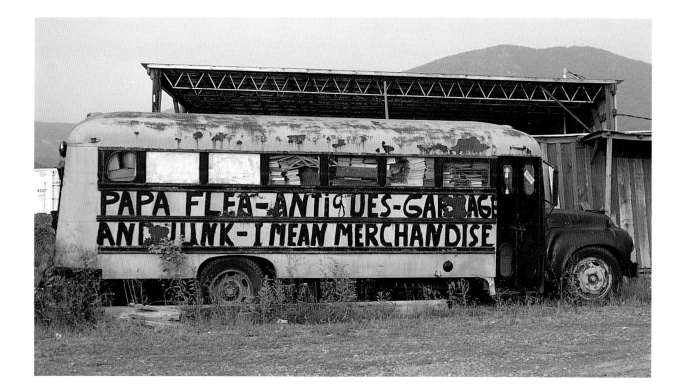

Papa Flea, in Ellijay, Georgia, stands prepared to deal in anything but the letter "Q," which gives him fits.

Automobiles frequently become communication centers. Painted cars are so unusual that they get a lot of attention. Because they are mobile they get a new audience constantly.

James Hall, a Nashville character, (now gone-to-glory) attached messages to every inch of his Nash Rambler. He lived in his car on Music Row in Nashville, near a popular restaurant and motel across from a battery of souvenir shops and around the corner from the Country Music Hall of Fame.

James was a preacher of low order and a panhandler of high degree. He thrived on tourists who shared his favorite performers, whom he clearly put on a pedestal every bit as tall as that of Jesus. A lovable con artist from the Bronx, James found comfort and cash in the streets of Nashville.

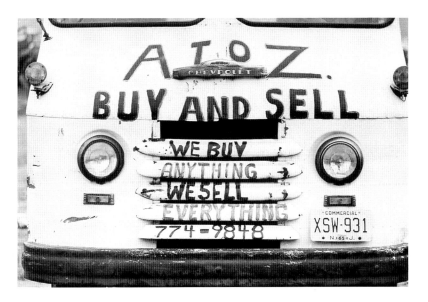

I don't know much about the junk business, but it seems that junk dealers have to advertise aggressively; even their trucks are used as mobile signs. Typically, they call themselves Acme or A Plus or, as in this case, A to Z, which suggests, as they insist, that they deal in absolutely everything. A to Z was parked in the same spot at the Englishtown, New Jersey, Flea Market every Saturday for a long time, maybe still.

Even merry old England has a lighter signage side.

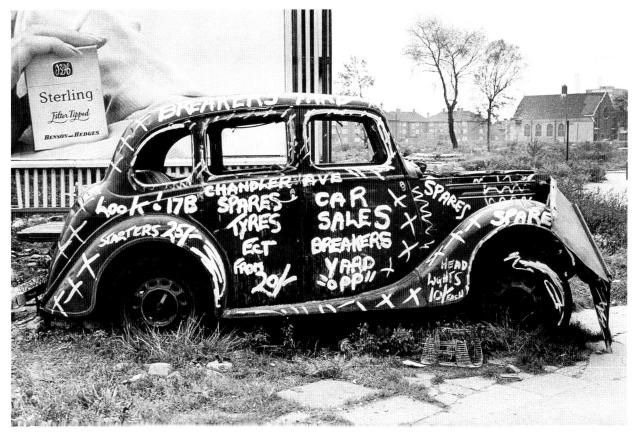

Apart from anonymously painted signs depicting the written word I value signs that picture the subjects they advertise. Some of my favorites are those for garages and automobile detailing shops. Next come beauty parlors, along with a list of hair do's and don'ts. Furniture shops, dance halls, pool joints, junk yards, and a host of other commercial enterprises provide a rich assortment of personal expression.

Food establishments, your basic mom 'n pop (or just mom, or just pop) eateries also offer painted treats galore. The omnipresent hamburger, dressed in its multiple personalities, is the most common; the hot dog runs second. I conclude this book with ubiquitous burgers and other favored subjects—faces and figures. No matter where one turns, there are attempts to paint the human figure and face with love, attention, and sometimes with skill. Always with determination, hope, and optimism.

This is, after all art *of* the folk, *for* the folk. Folk art.

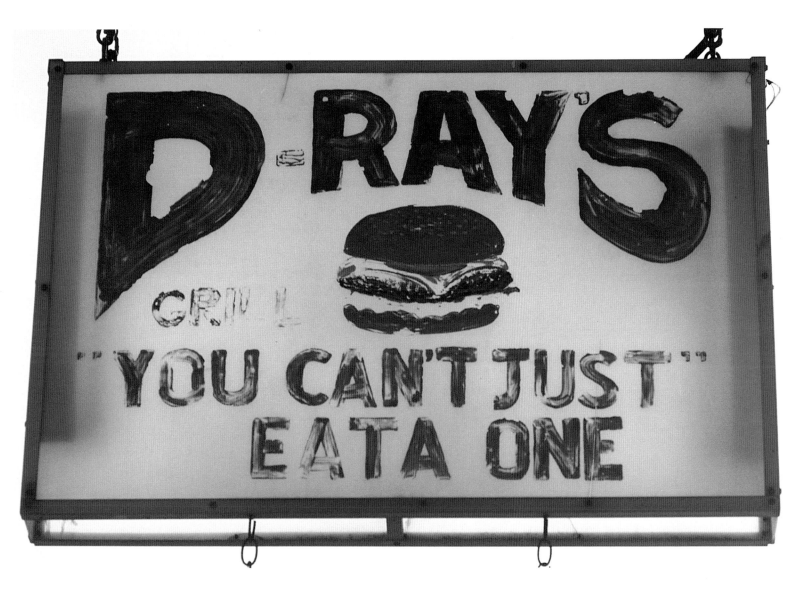

The photographs that follow offer a gallery of more or less appetizing food images. You may sometimes have to guess at what is being served.

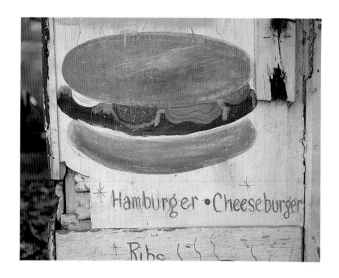

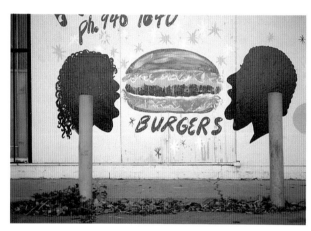

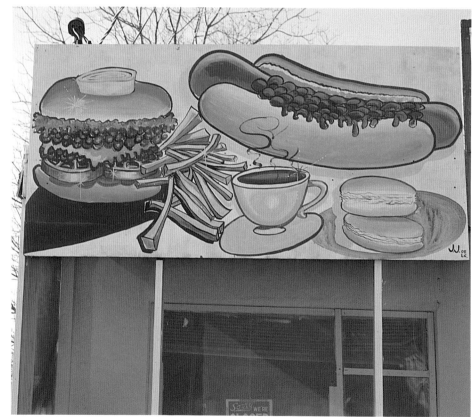

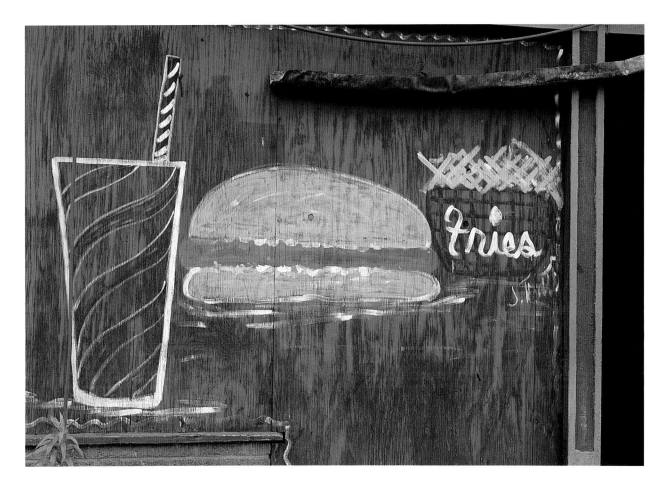

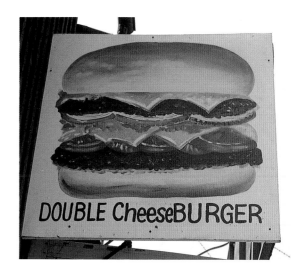

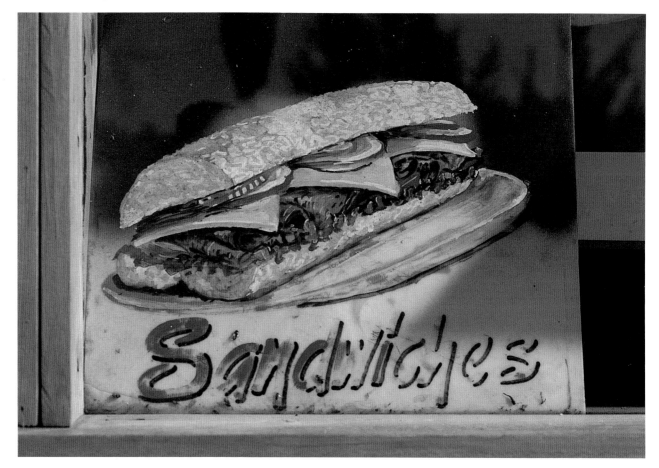

After moving to Nashville, I stumbled across the "Bar-B-Cutie" drive-in. Legend had it that the original Barbie was a vivacious car hop who always wore tightfitting blouses and short short skirts. She was immortalized in a cutout sign of painted metal that hung on a tree in the parking lot. I made a photograph of the Barbie sign for my archive.

A dozen years later I got a call from antique dealer Bill Powell, who knew my interest in roadsidiana. He had a figurative car hop sign that had been used as an attention getter at tag sales. When I saw "her," there was something mysterious and elusive that I couldn't figure out. Nevertheless, I bought the sign, took it home, and hung it on the wall.

Still more years later when I was rummaging

through photographs for this book I came across my shot of Barbie Cutie, and I knew instantly that I owned her; she had lost her oversized Stetson and been completely repainted, but there she was on my wall. Barbie had come back to me. I was in sign bliss. Patience *is* a virtue.

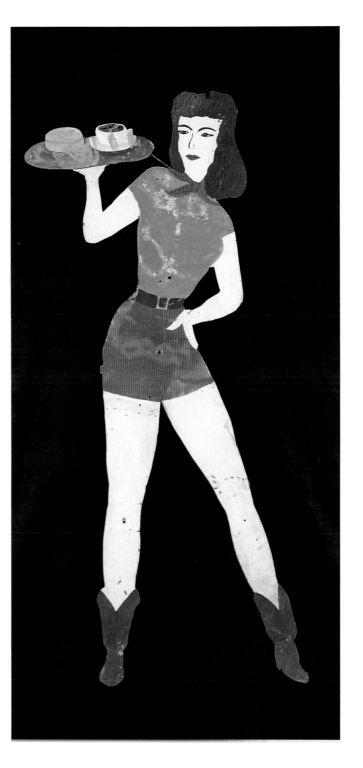

At this bar in south central Los Angeles I couldn't figure out the significance of the four Stars of David. But if you look at the expression on the face of the filly in the cocktail it seems to suggest "What's a nice Jewish girl like me doing in a place like this?"

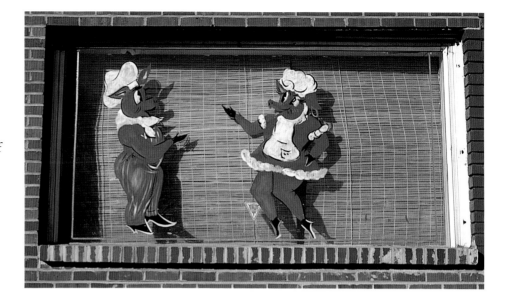

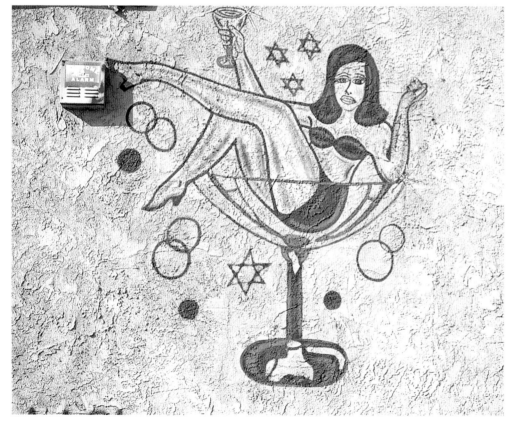

Two stylish chefs invite attention to a Bar-B-Que shop in Nashville.

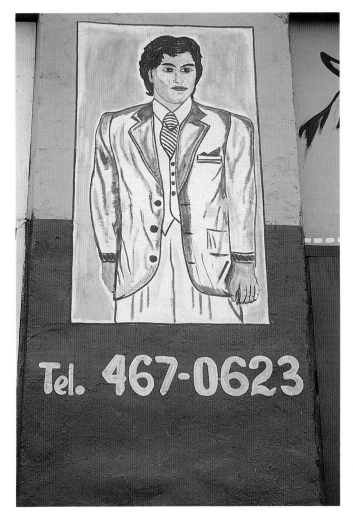

Unless I miss my guess, this tailor shop in Los Angeles, on lower Melrose Avenue, specialized in alterations for the full figure woman and big man.

I'm not sure what this Cleveland photo studio was offering except looks up the skirt of a zoftig lady, but the bas-relief figures are sign art of a high order.

This five-foot-one-inch-tall figure was acquired at a fancy antiques show in Nashville. The roadside relic had been attached to a gas station wall, with the air hose wrapped around the arm and protruding belly.

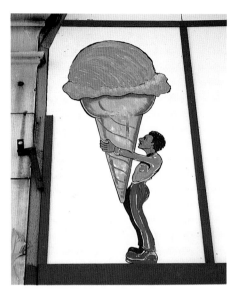

For dessert you can have an ice cream cone so large and delicious that you'll get excited in more ways than one.

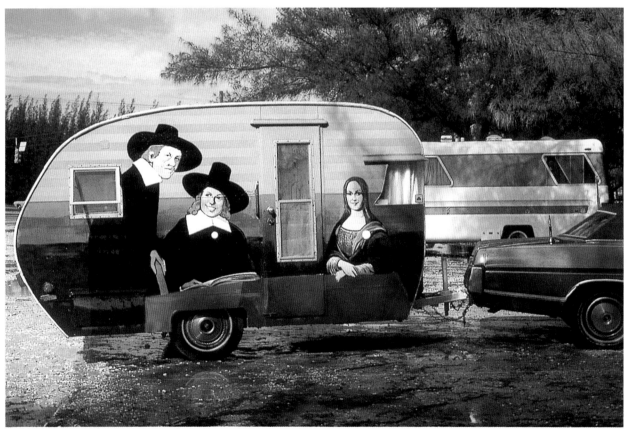

Finally, although it's not a sign, I couldn't resist this expertly painted trailer, on which the Mona Lisa meets the Dutch masters, a cheerful reunion for all.

There are no endings,
only beginnings.